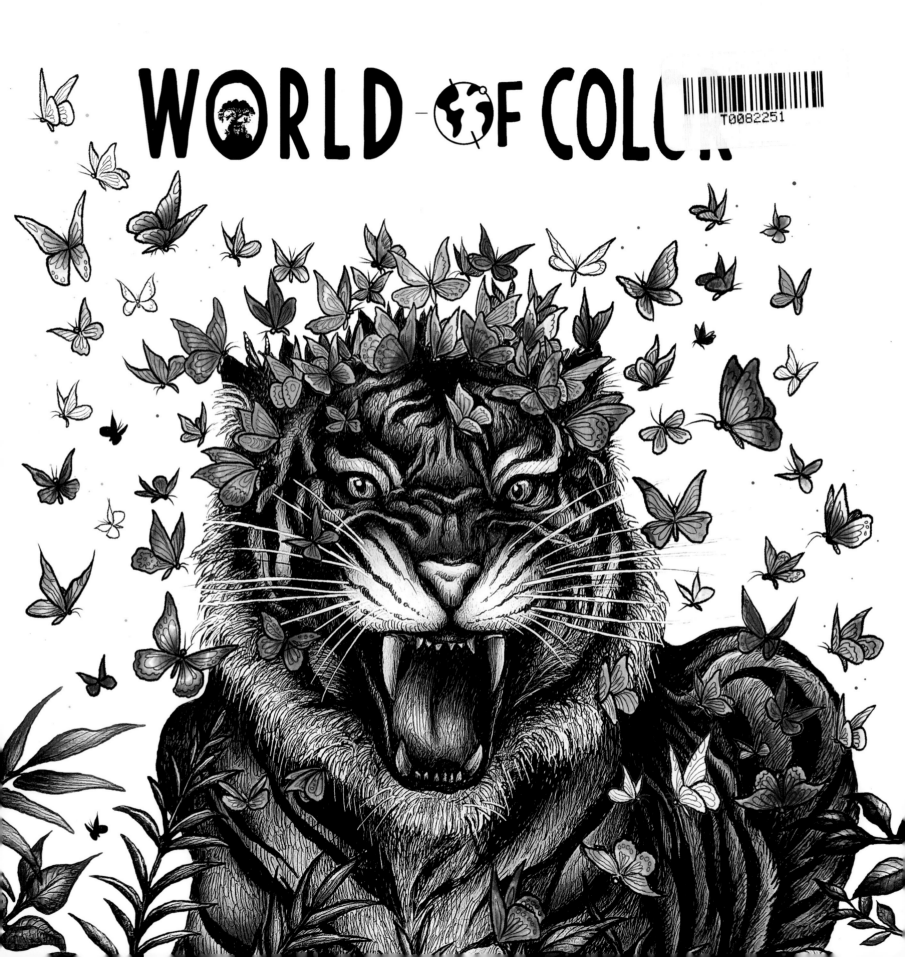

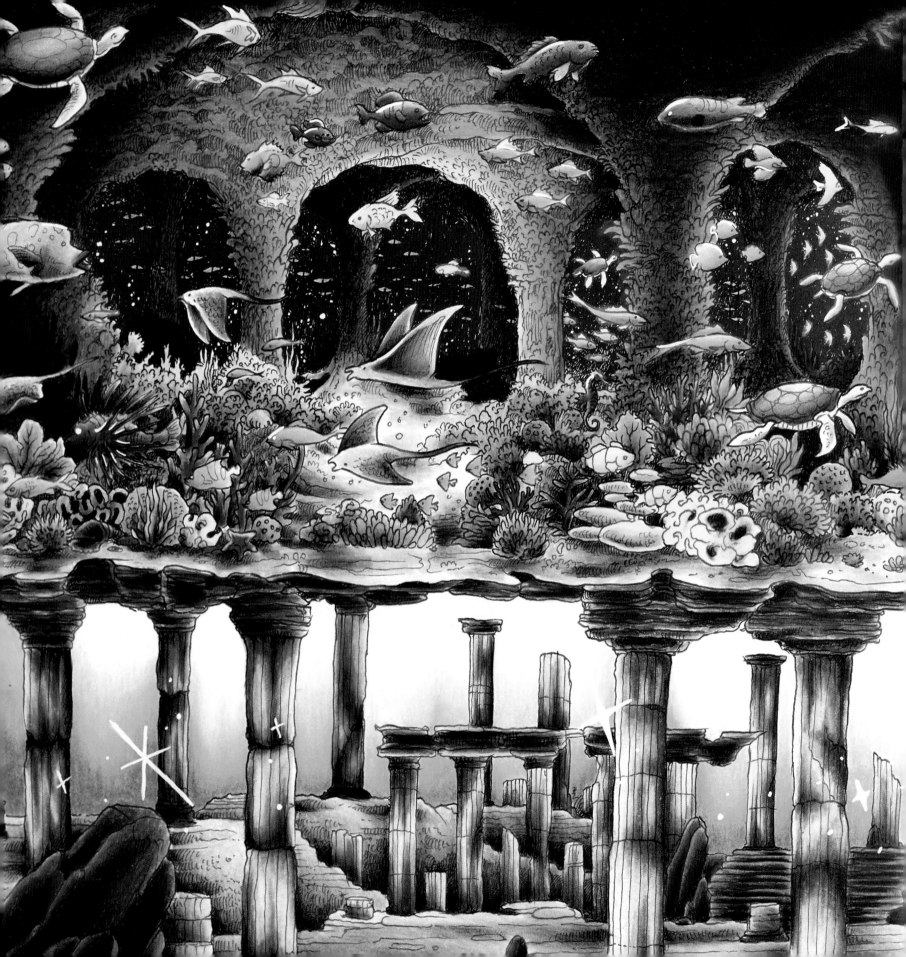

Take a magical coloring journey . . .

Marvel at the natural beauty of our fragile planet, and explore imaginary realms with strange landscapes populated with mythical beings.

In this book, you'll find a collection of my favorite images from across my **World** series. They're ready for you to bring to life with a whole world of color.

To inspire your creativity, I have included a selection of images completed by some exceptionally talented colorists. Discover their choices of color palette, skilled blending and shading techniques, and their own creative additions and innovations. I have described what makes each piece so special and suggested coloring tips and tricks that you can use in your own work.

It's time to be inspired to create your own coloring masterpieces.

Kerby Rosanes

Worlds Under Water—Achieving the Impression of Depth (previous page)
Colored by Carène Francois, aka @ti.bouch

This stunning underwater world showcases a wealth of coloring techniques and skill. Flawless blending and graduation of hues—from acidic yellows to dark forest greens—is combined with heavy black shadows within the arches to give the impression of light penetrating the cavernous depths of an ocean.

The white outlines around the jellyfish, added using a white gel pen, describe their translucency and ethereal beauty, while emphasizing the impression of depth behind them. The colorist has chosen complementary colors that sit opposite each other on the color wheel for the vibrant foreground detail—from teal marine life and orange aquatic plants to sharp accents of lime green and fuchsia pinks. These pops of color plunge the contrasting dark, shadowy caves further into the background.

The pink fish and corals stand out against the predominantly green composition of the upper half of this image, and also echo the pink-toned pillars below. Reflecting hues of color in this way keeps the eye moving across the page, maintaining a connection between the two halves of the scene.

In contrast to the mysterious caves, the lower half of the image is flooded with light. The background graduates from aquamarine and cerulean blues to cyan and Arctic blues. This gives the impression that the underwater ruins are nearer the sea's surface. Using a white gel pen, highlights and twinkling points of light have been added throughout the lower half of the image, emphasizing this idea of sunlight shining through the water from above. They add a touch of magic and mystery to this beautiful watery scene.

Gentle Giant—Exploring the Intricacies of the Natural World (facing page)
Colored by Éva Szafoe, aka @szafoe

The colorist has achieved a stunning representation of our natural world in all its wonder, seamlessly blending this magnificent ape and a mysterious mountain landscape.

The gorilla's fur, comprised of gray tones with golden-brown highlights and deep shadows, is beautifully rendered to simultaneously resemble realistic animal fur and a rocky, mountainous surface.

Added texture on the treetops, mountain crevices, and fur melds the wild animal and its habitat together. Small bursts of red in the animals scaling the "gorilla mountain" catch the eye and draw the viewer further into this landscape.

A striking feature of the background is the ethereal, moisture-filled quality of the clouds, which has been achieved by dabbing white acrylic paint onto the page with a sponge. These clouds generate a magical ambience and, to me, emphasize the mysteriousness of this animal and its world.

The colorist has chosen a soft green for the sky, conveying a sense of harmony between animal and nature. The soft color palette used throughout the image reinforces a sense of calm and highlights the gentle grace of the gigantic beast.

From the mountainous landscape and misty clouds to the rushing waterfall and strikingly realistic facial features, the colorist has created a stunning piece of art.

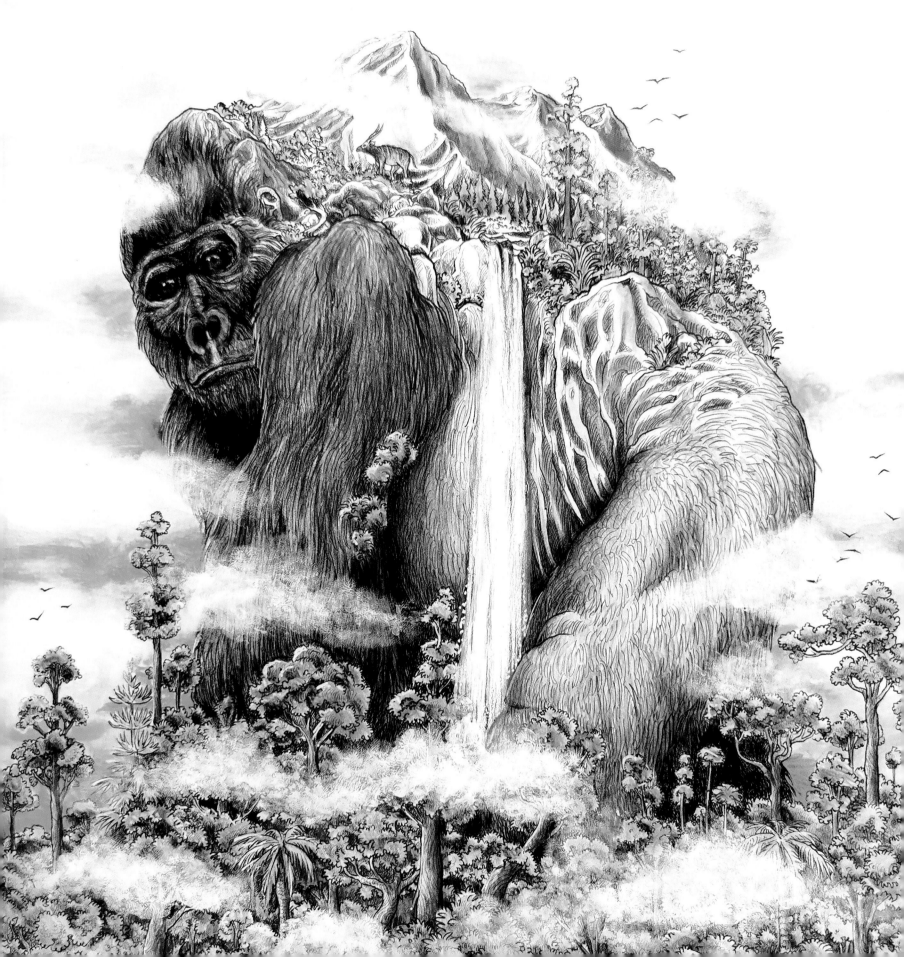

Sunrise Stork—Making a Magical, Dreamlike Scene (facing page)
Colored by Elena Burtasova, aka @elena_burtasova_

This picture captures the magic of golden, morning light as the colors of a rosy dawn cast a rich glow across the page. Starting with the pastel-yellow sunlight breaking through the clouds in the top-left-hand corner, the background colors migrate diagonally downward toward richer pinks in the lower-right-hand corner of the image. The effect is a breathtaking sunrise.

The colorist has achieved the impression of a dewy, radiant, and light-filled sky by first applying a watercolor paint wash over the page, then deepening the colors with pencils, using them to add shadows and highlights.

The picture uses a stunning limited color palette. Soft, dreamlike pinks have been chosen as the theme, with bright magentas for the body of the bird and softer pinks in the sky. Contrasts of yellow throughout give an enchanting, otherworldly glow to the image.

Accenting the head and the structures on the back of the stork with bright yellow and coral tones, as well as picking out golden trees using gouache paint, creates the impression of light reflecting directly from the rising sun.

The colorist has dotted white sparkles around the sky, on the bird's feathers and beak, and added highlights to the crests of the clouds, enhancing the portrayal of shining sunlight. Picking out the flying storks in darker, magenta tones creates a sense of depth within an expansive, hazy sky.

Botanical Illusion—Creating a Lustrous Iridescence (next page)
Colored by Sophia Eagle, aka @sophia_coloring

This colorist has created a spectacular piece comprised of wondrous living worlds. Each windmill scene within the hanging terrariums portrays a different season. An incredible level of detail has been used to illustrate each fragile ecosystem. Starting with the sun shining high in the sky creating a balmy summer light in the windmill world on the left, this stunning picture moves through the climates of the year. It progresses through the blossoming tulips of spring and the snow-topped trees of winter to the warm colors and rainfall of autumn on the right.

Most striking is the reflective shine effect achieved on the surface of the hanging glass baubles. This adds an impressive three-dimensional aesthetic and ensures the mini worlds gleam with a delicate iridescence. They even appear to take on the fluid atmosphere of the background, becoming like suspended bubbles, liable to burst at any moment. The impression of light bouncing off the glassy, watery surfaces is created with white gouache paint and a white marker. The colorist has also used these materials within the windmill worlds—adding intricate highlights throughout the image, on the flowers, trees, and windmill rotors.

Using watercolor paint for the background, in a wash of dark gray tones with lighter gray and white circle patterning, is reminiscent of falling raindrops and adds a moody and stormy cloudiness to the image. The dark background intensifies the reflective luminosity of the pendulous worlds and amplifies the bright and colorful vibrancy of the plants and windmills within these transformational terrariums.

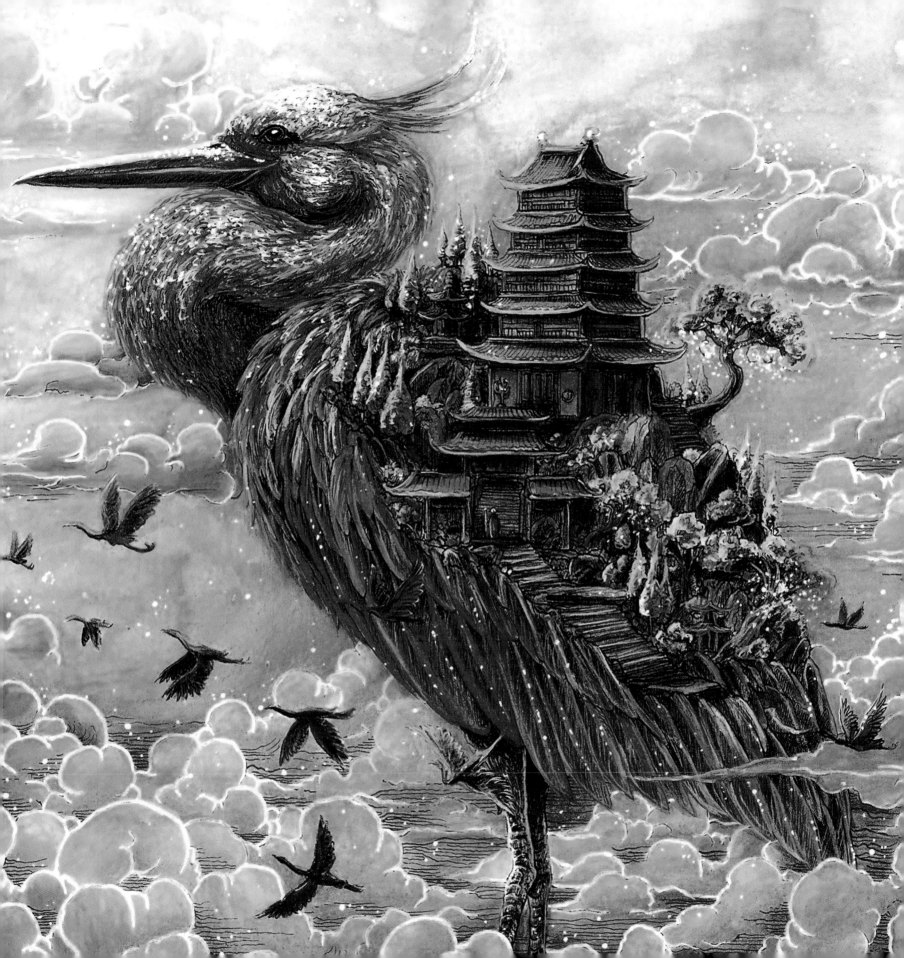

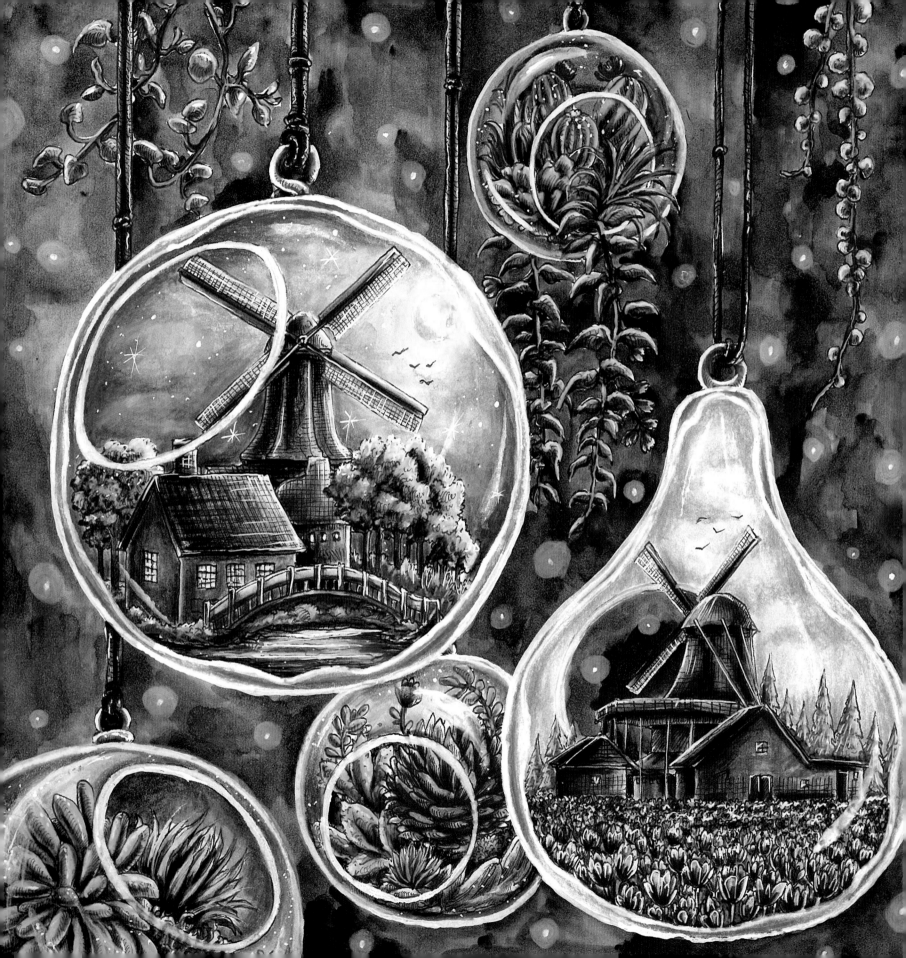

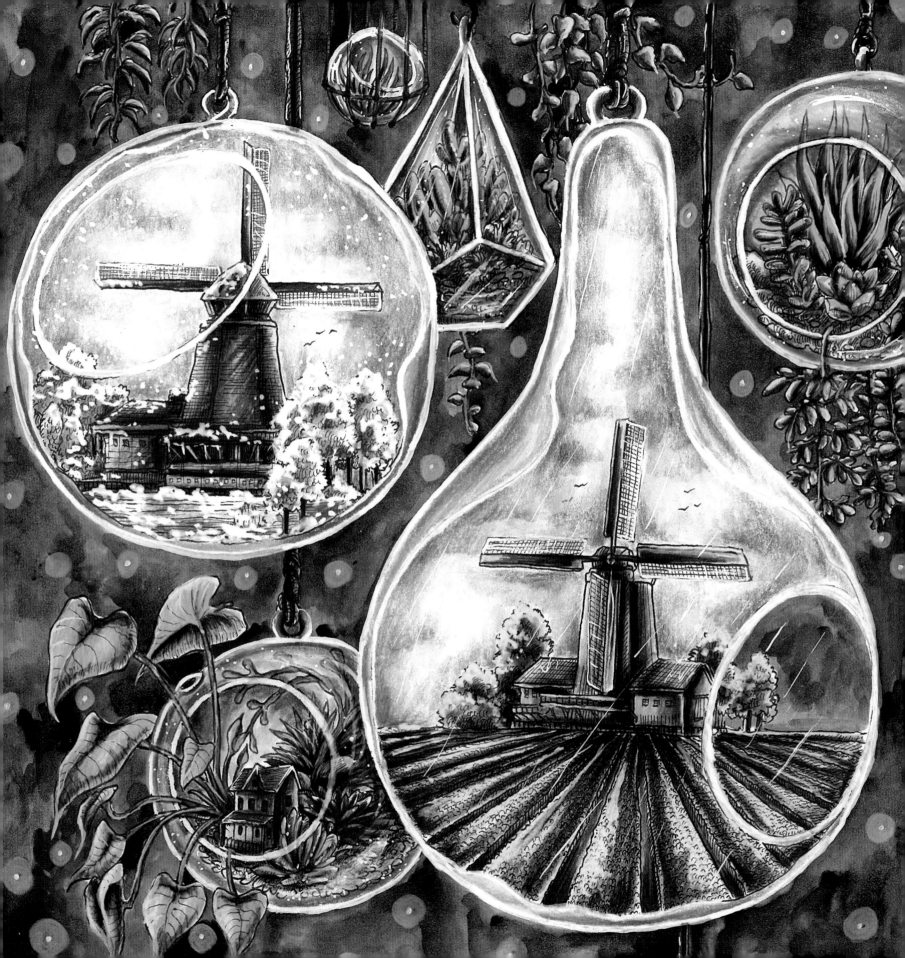

Entrancing Tiger—A Lesson in Juxtaposition (facing page)
Colored by Lina Amir, aka @noogie_13

In this stunning image, the powerful ferocity of the tiger has been juxtaposed with the delicate fragility of a halo of butterflies, softening the aggression of this arresting animal.

The colorist has made use of opposing color palettes and varying techniques in an imaginative way. The elegant background and dainty butterflies have been colored in gentle, more mystical, pastel-toned blues and pinks. These are contrasted with the stark and strikingly realistic orange, yellow, and black colors and shading of the tiger.

Colors that sit opposite each other on the color wheel are known as complementary. Using these opposing colors—such as pink and green or orange and blue—creates a dynamic contrast between the different elements on the page, as the colors appear to vibrate against each other.

By coloring the grasses and foliage in surreal cobalt blues and amethyst purples, the colorist has built an air of mystery and etherealness to the environment of the crouching tiger. The technique of shading from darker to lighter tones within this foliage creates a sense of luminescent depth.

The colorist has added heavy black outlines and detailed white patterning to the butterflies, drawing on the striking wing markings of the monarch butterfly. These innovative additions take this picture into another dimension.

Interstellar Innovation—Creating a Cosmic Glow (next page)
Colored by Karen Stivala, aka @mycolourfulcountrylife

Using a combination of intricate shading and masterful blending, this colorist has created a striking light that radiates off the page. The explosion of starry detail, added to the rich, dark background using a white gel pen, makes for a truly dynamic and awe-inspiring celestial scene.

A glowing effect is used around the Earth and Moon to suggest their shining atmospheres. The same technique is used to surround the underwater elements in nebula-like swathes of neon pinks, blues, and oranges. It is as if they are racing toward Earth within magical interstellar clouds.

To contrast with the bright, otherworldly tones in outer space, the colorist has chosen a softer, more natural palette for the earthly elements. They have used rich greens and azure blues going into darker navy shades for the Earth's surface, and depicted the comet in the colors of the Great Barrier Reef. These hues, in complementary shades of pink, green, orange, and blue, work with the surrounding bold, neon shades to create a colorful feast for the eyes.

The fiery head of the mystical meteor has been colored in a punchy, bright yellow, capturing the drama of a burning meteor blazing through the cosmos. Using black and navy tones for the deep background of space ensures these colorful elements zing into life and jump off the page with dazzling vibrancy.

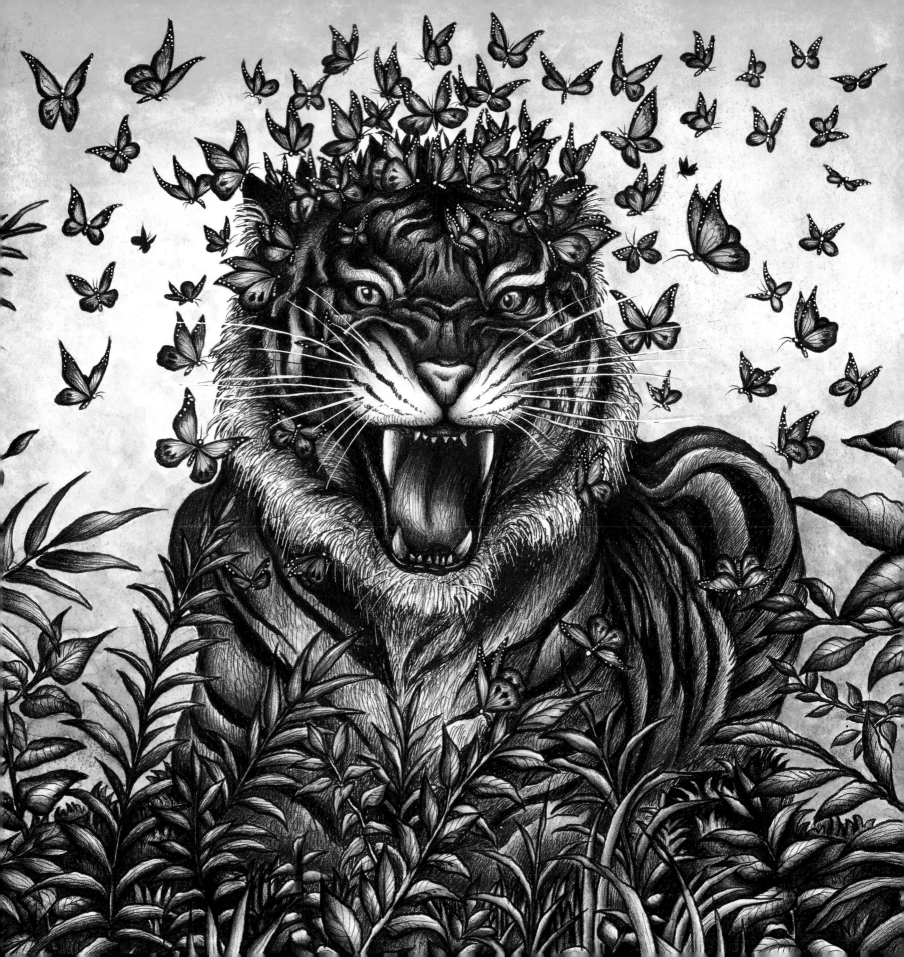

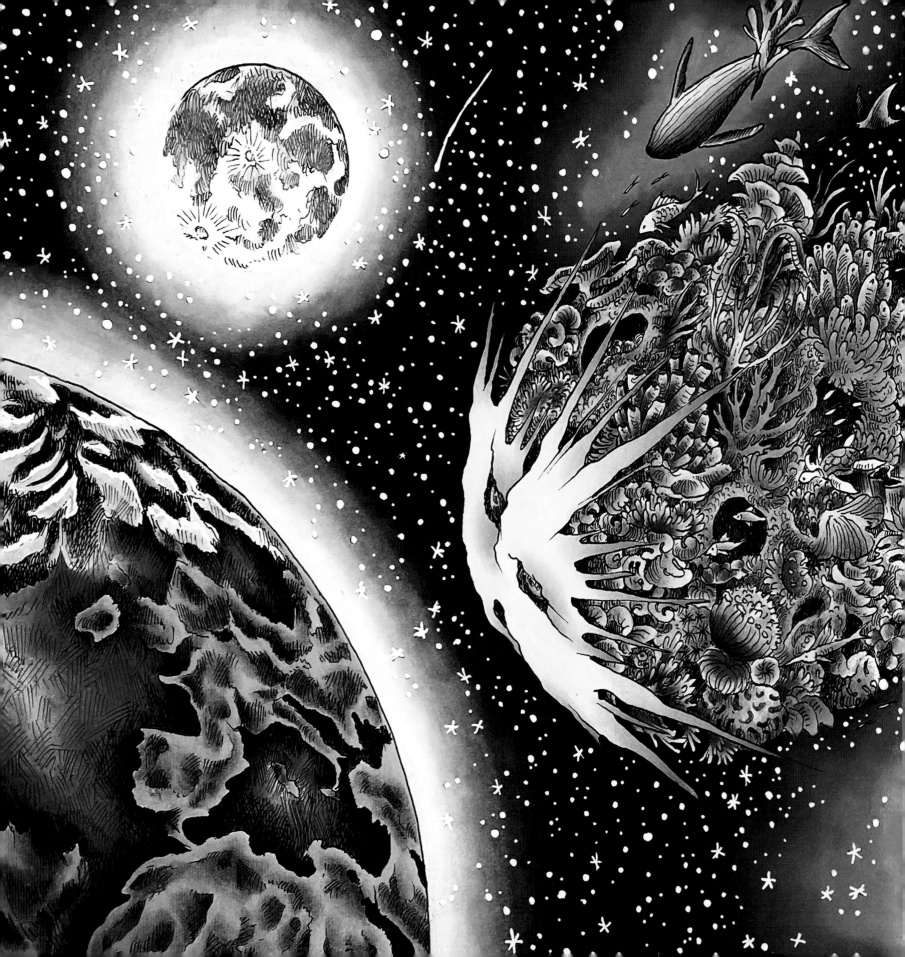

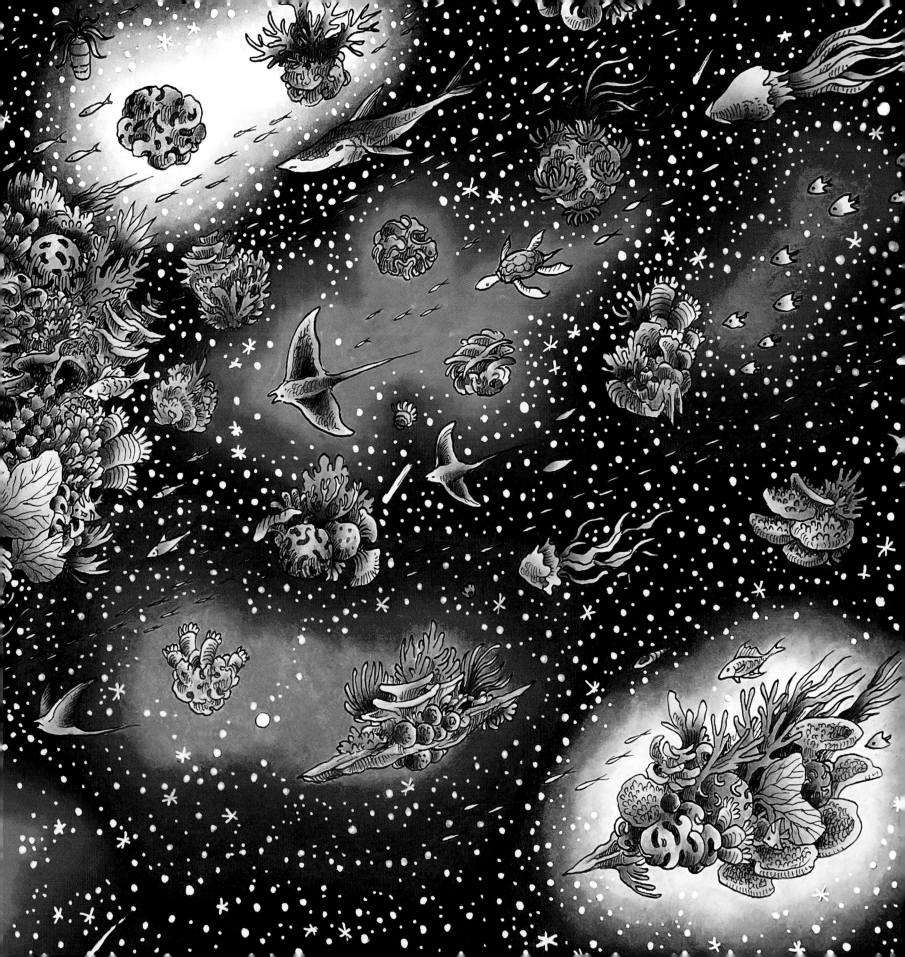

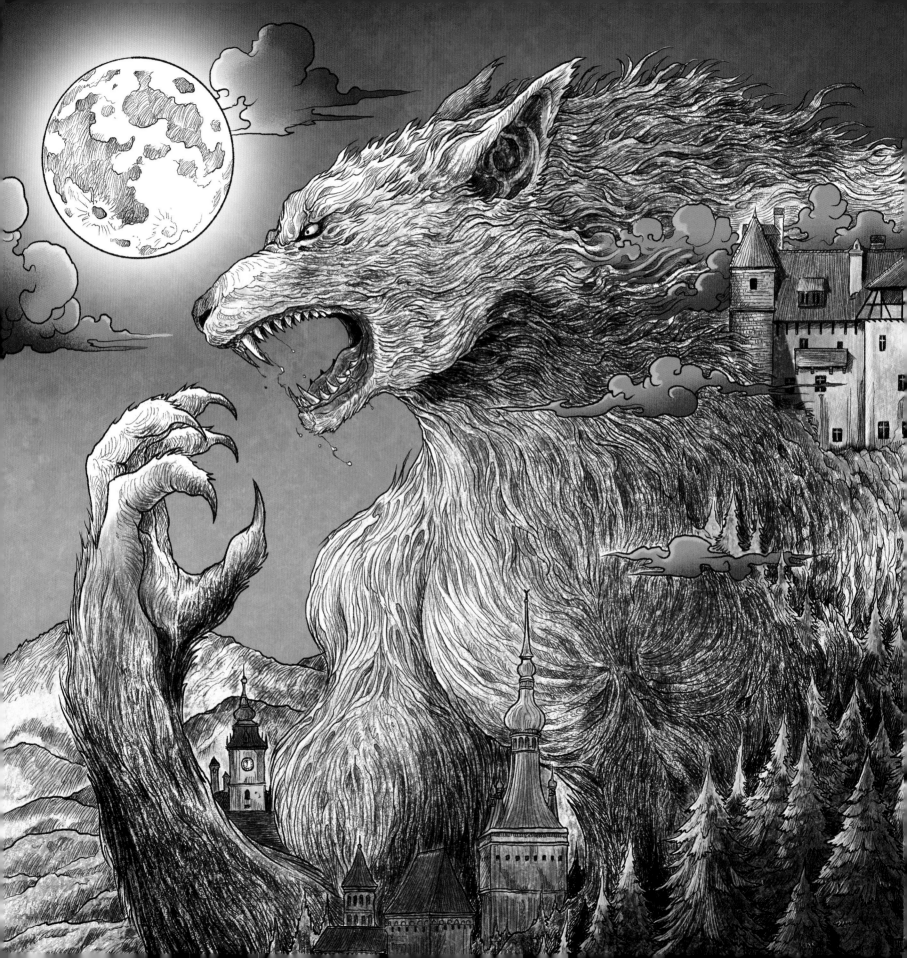

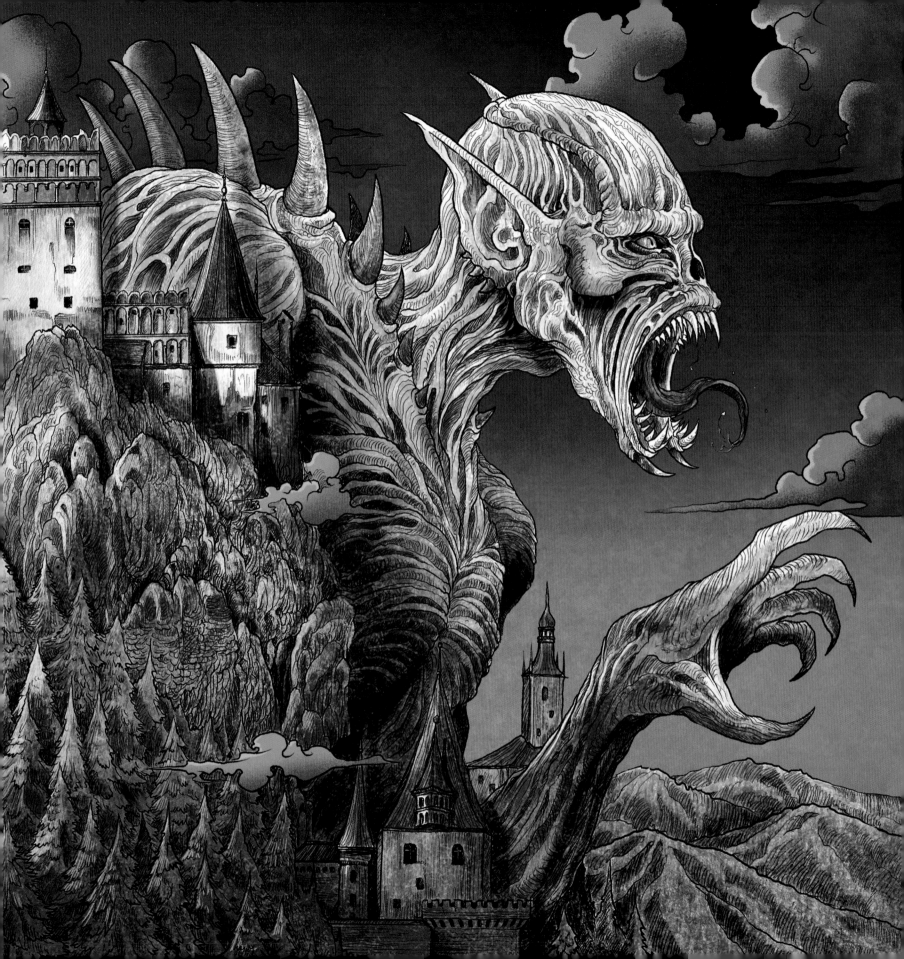

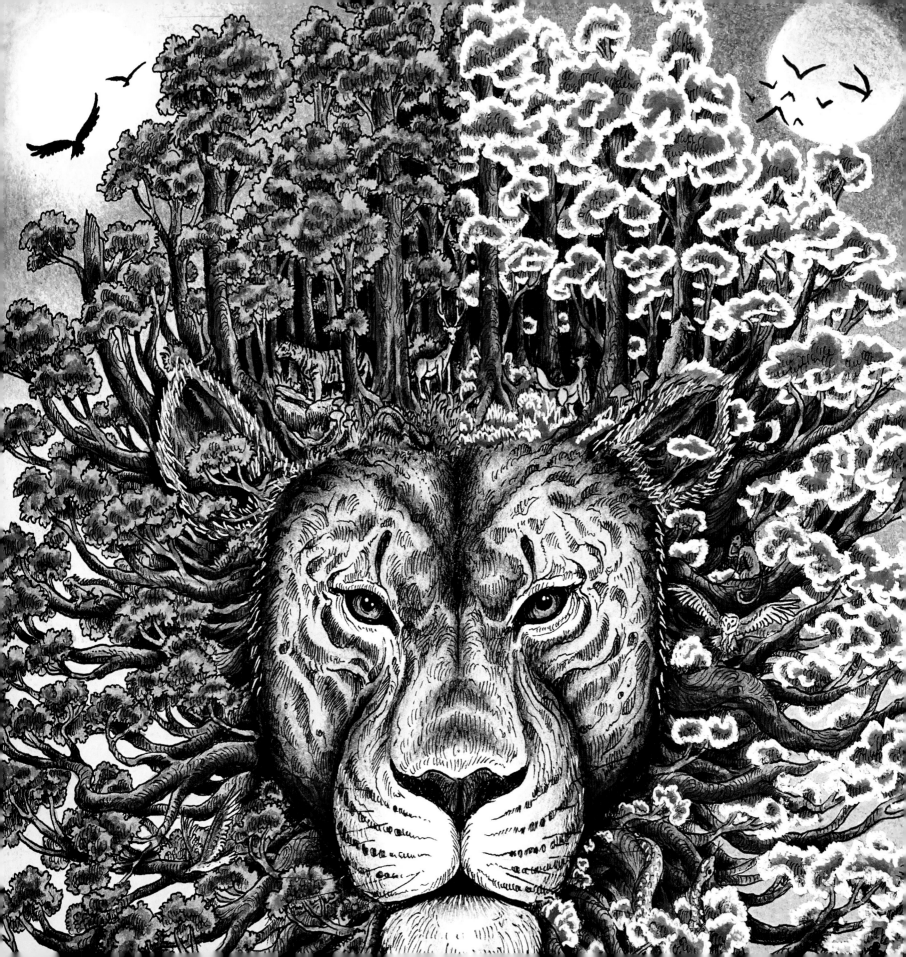

Mythical Monsters—Combining Traditional and Digital Techniques (previous page)
Colored by Derrian Bradder and John Bigwood

Bruise-like purples and unsettling icy blues give a dark and dramatic feel to this haunting piece. These cool and moody tones are broken up with powerful bursts of contrasting brighter color throughout, from the yellow and pink in the werewolf's fur to the burnt orange of the castle turrets and the green of the treetops. This rich spectrum of color is illuminated by moonlight.

The color of the sky behind each monster changes to reflect the dominant colors used for the mythical beasts in reverse, ensuring the powerful creatures stand out against the night sky. The glowing Moon casts highlights over the nighttime scene, and these areas of ghostly light bring these magical creatures to life.

This striking piece also demonstrates how traditional coloring techniques combine with digital tools and effects to produce stunning results. Colored first using pencils, the image displays a hand-rendered texture of rich blending throughout. The artwork has then been scanned into Photoshop—a graphics editing program—to digitally enhance the image and create stunning additions. A digital texture has been overlaid on top of the colors, to mirror the hand-rendered elements, and, finally, pencil and brush tools have been used to enrich tones and add highlights to the shadows. The effect is a dramatic contrast between colors, accentuating form and detail.

Cycles of Nature—Building a Narrative Through Color (facing page)
Colored by Lolita Nelipovich, aka @my_colorful_peace

With cool wintry blues in a moonlit background contrasting with sunny oranges and a vibrant forest-green woodland, this colorist has created an innovative image of two halves.

Their choice of colors creates a captivating story of the cycles of nature. On the left, colors associated with the blazing heat and flourishing greenery of summer move into autumnal shades of orange. On the right, a cherry blossom pink reflects spring, bursting through accumulations of white snow on an icy background of winter blues.

In addition to representing the seasons with color, the colorist has juxtaposed night and day with the addition of a Sun and Moon on either side of the image. The sunrise yellow of the left-hand side complements the sunset pinks on the right. The chestnut and tawny brown shades of the tree trunks seamlessly emerge from the lion's features, which have been colored in rich golden and deep yellow-brown tones. This symbiotic relationship of living things represents another cycle of nature.

The overall attention to detail in this piece is truly remarkable. Deep shadows and textured blending on the lion's face achieve an impressively realistic effect. A subtle hint of green in the lion's eyes further roots this majestic animal to the surrounding landscape. It is the interplay of these extraordinary details, along with the contrasts and oppositions of color, that together evoke the transience of nature.

Coloring section

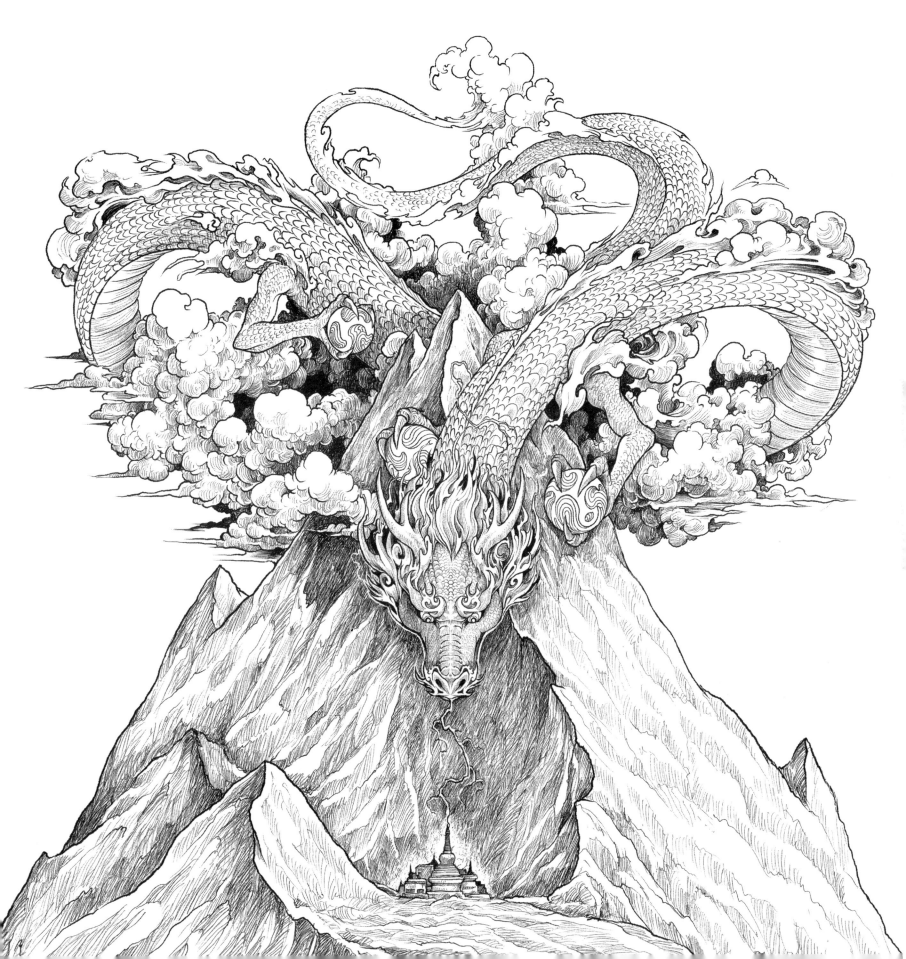

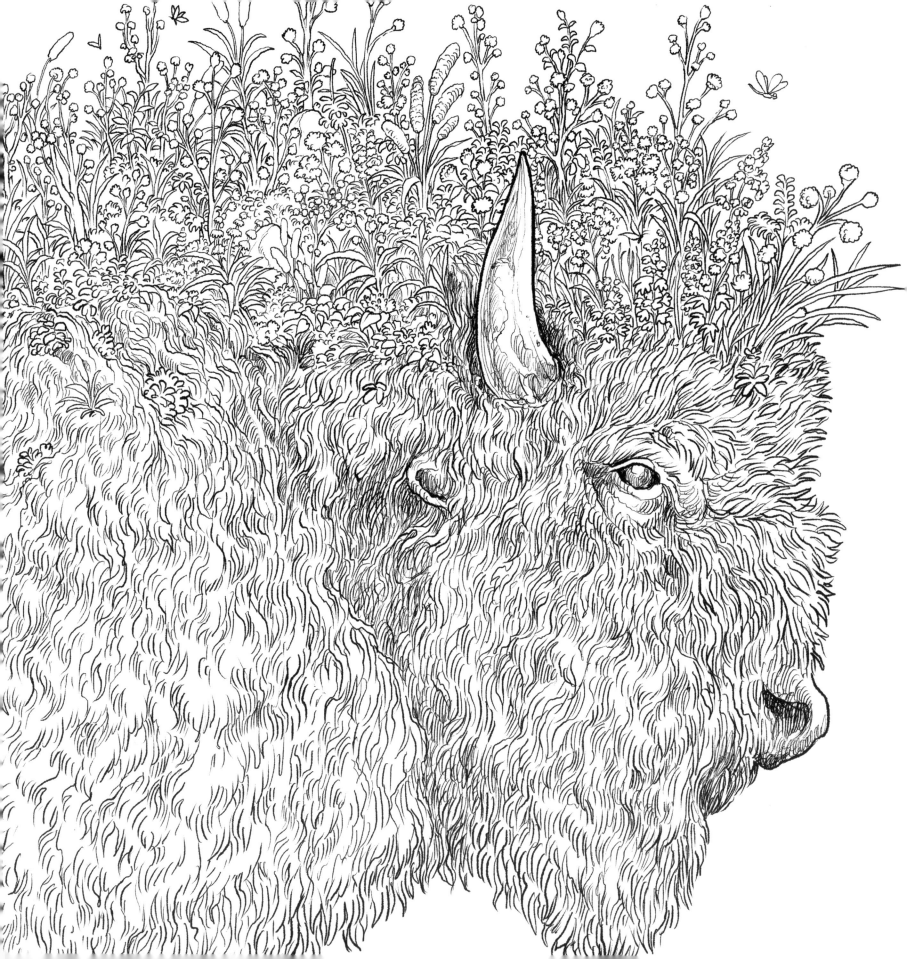

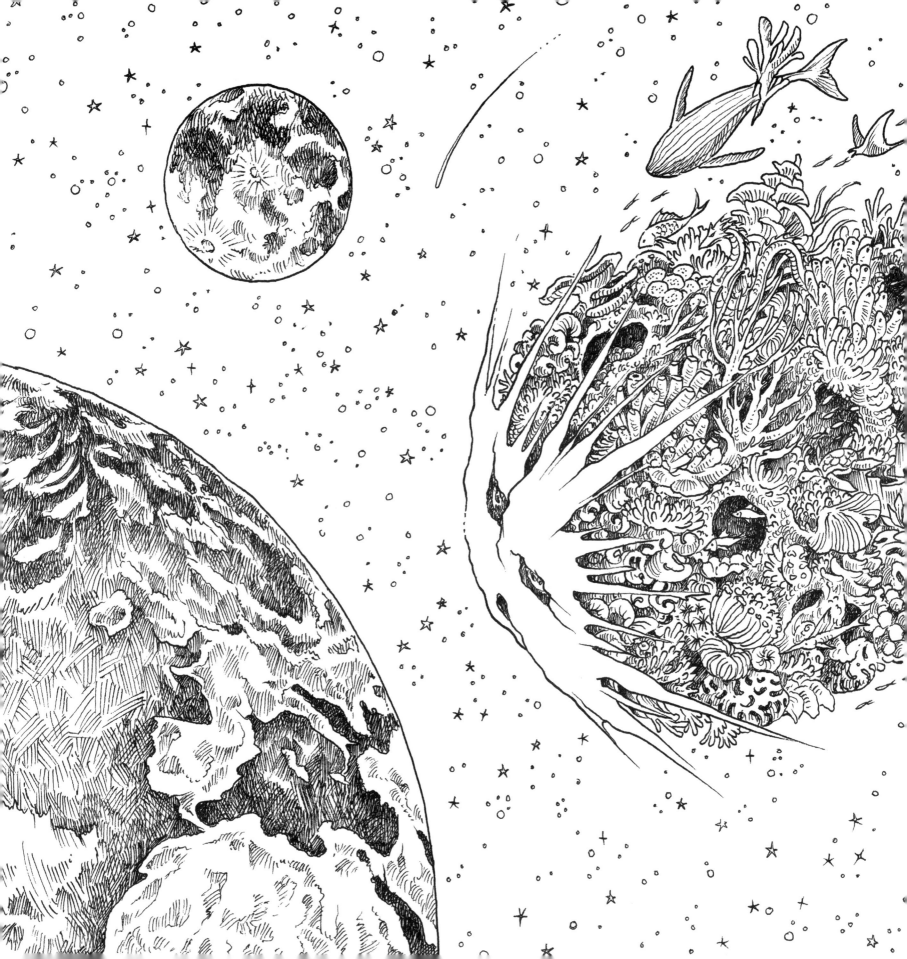

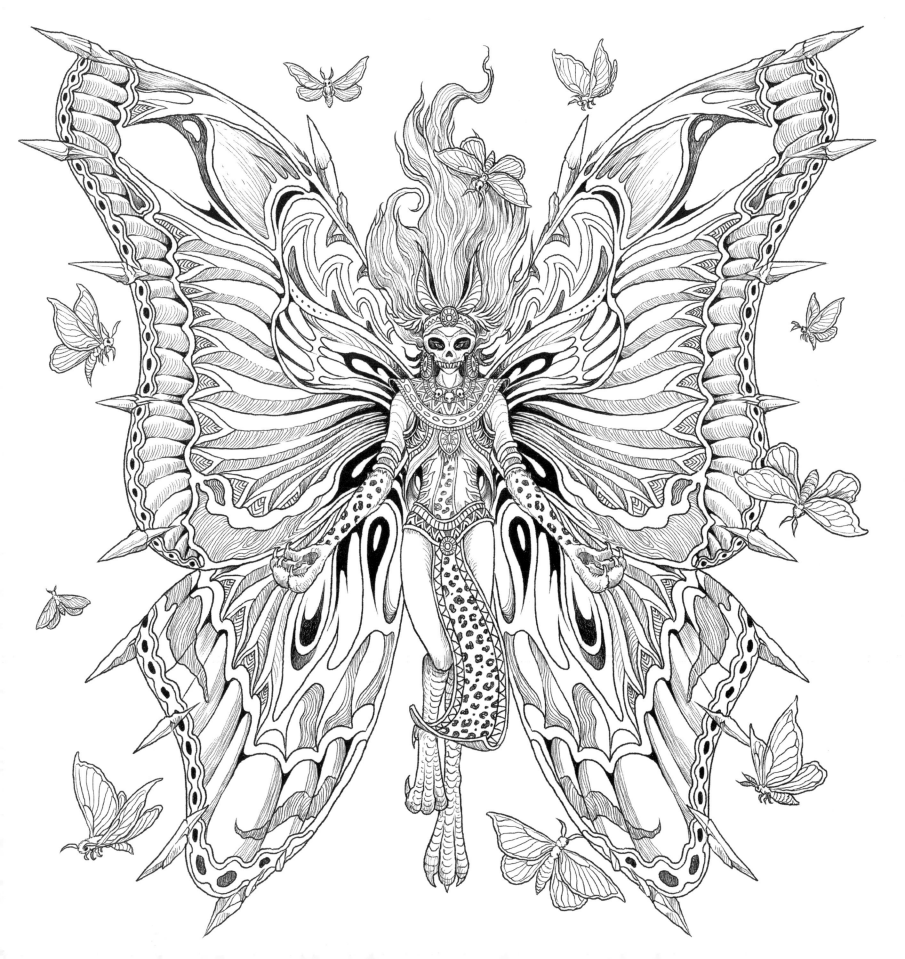

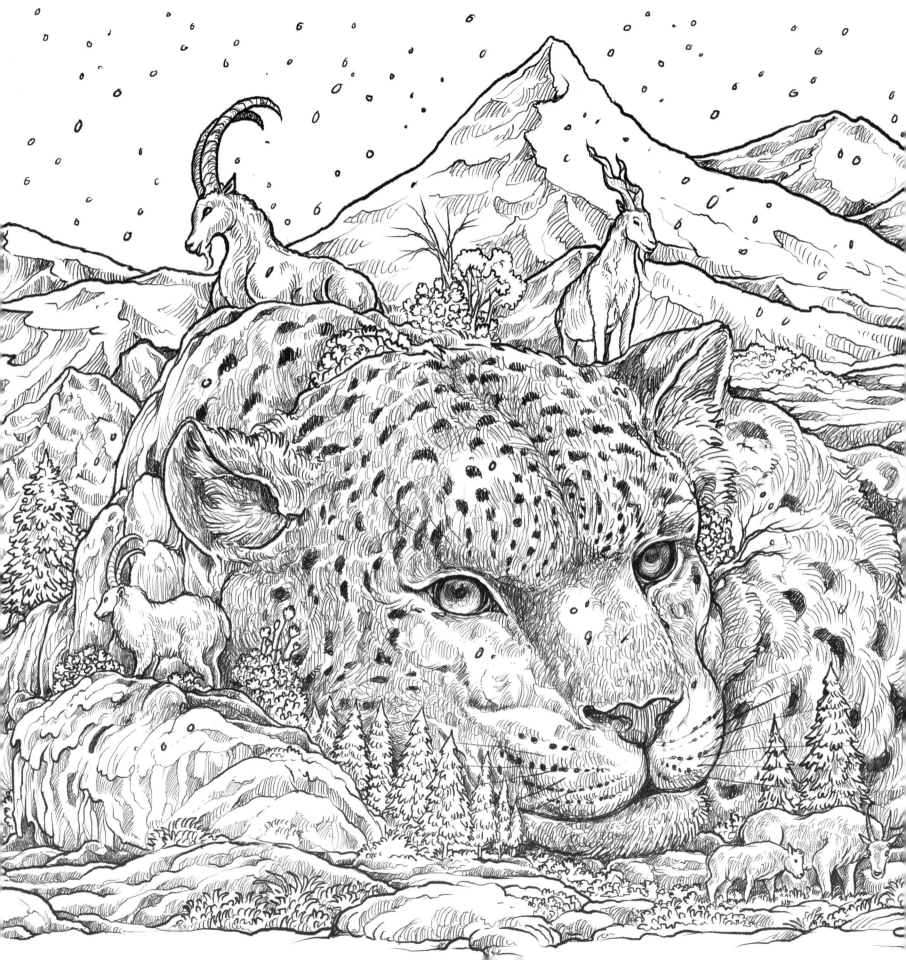

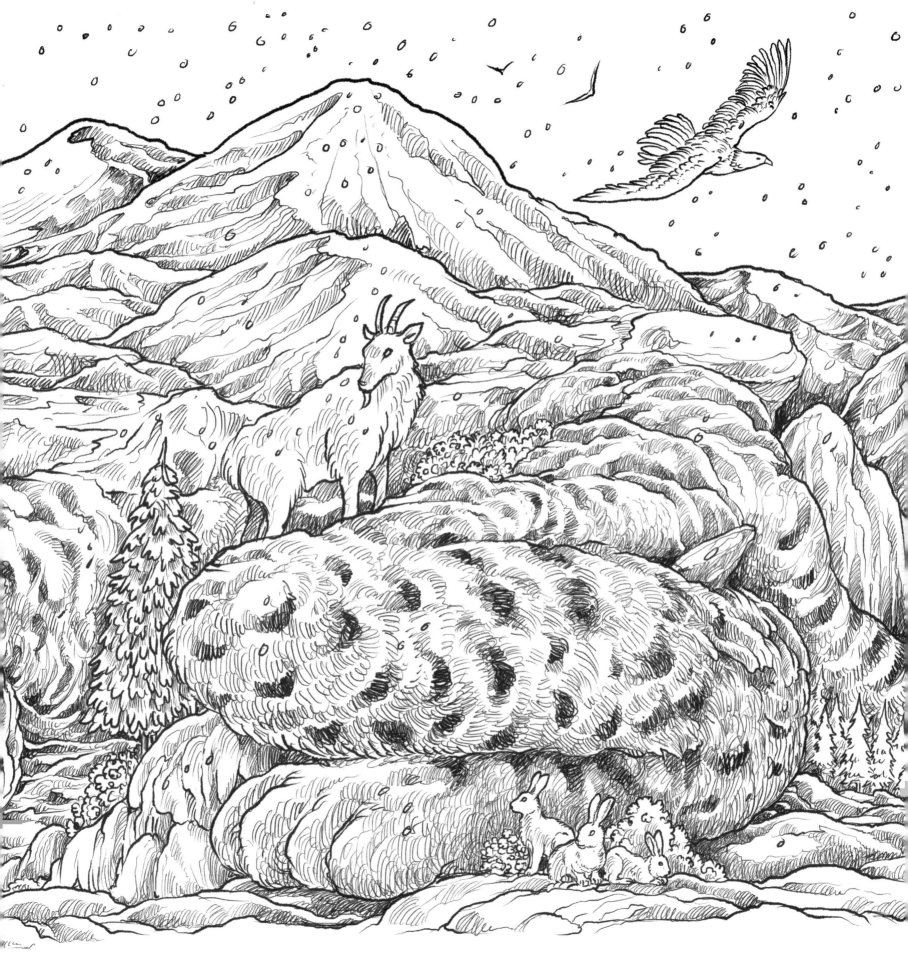

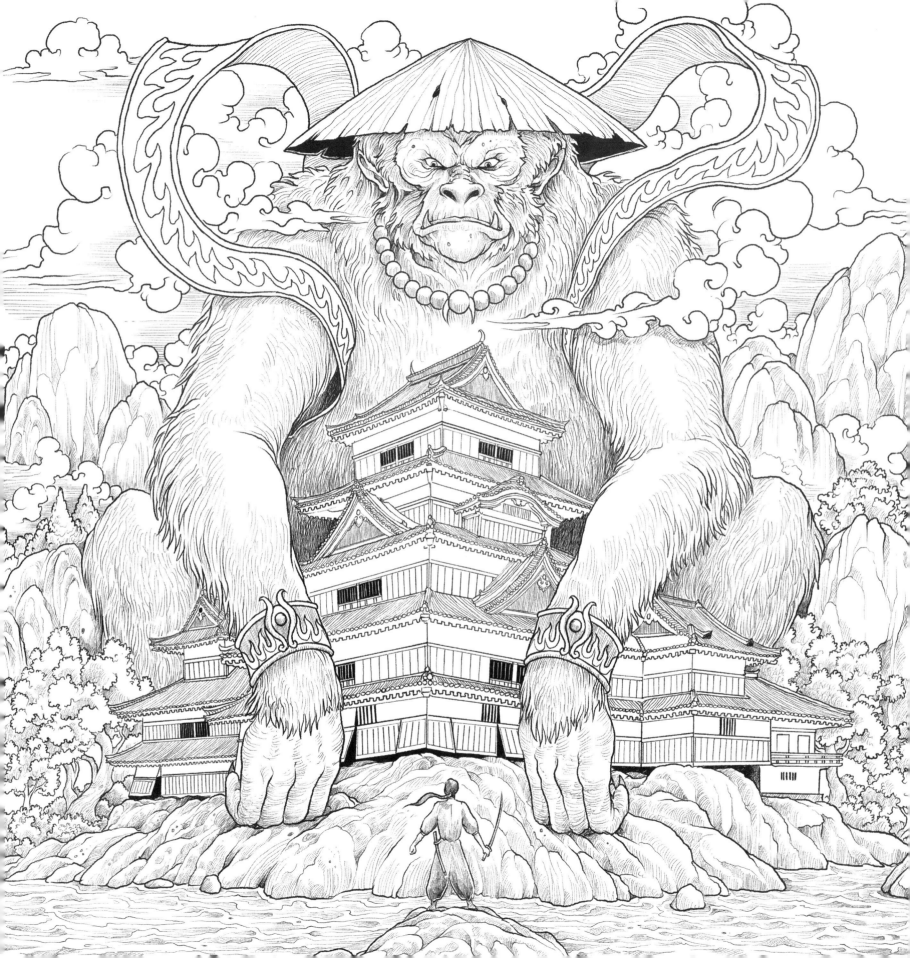

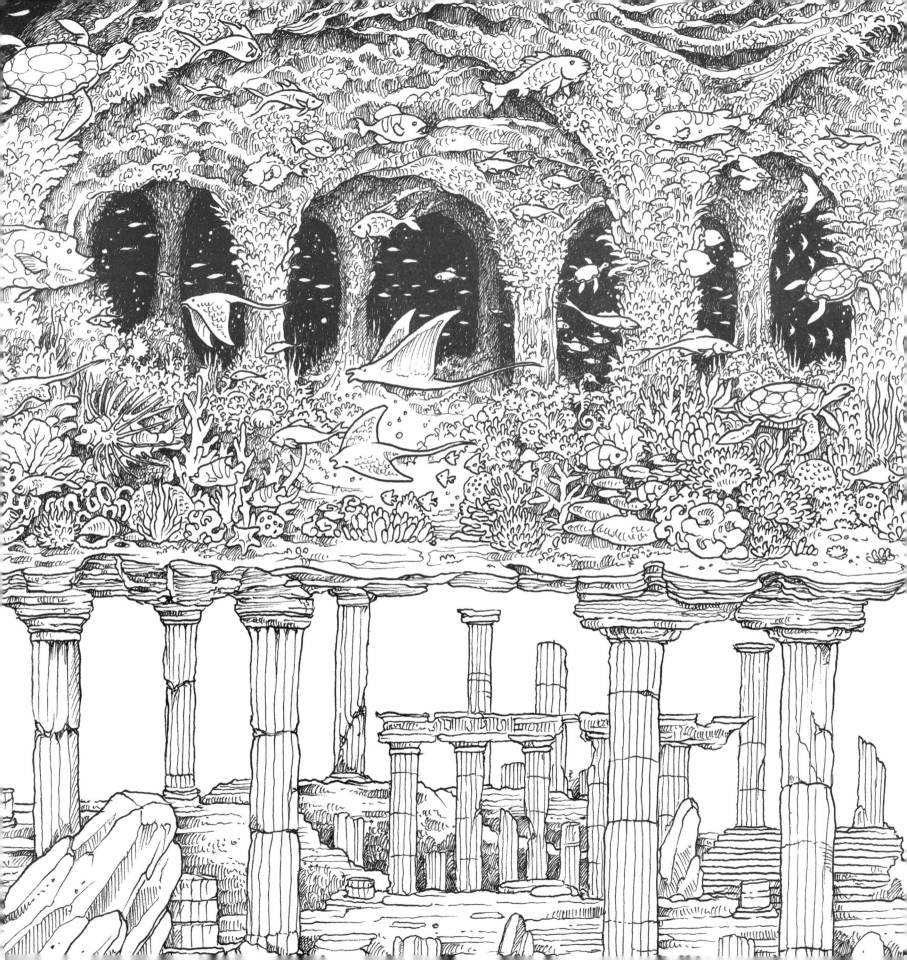

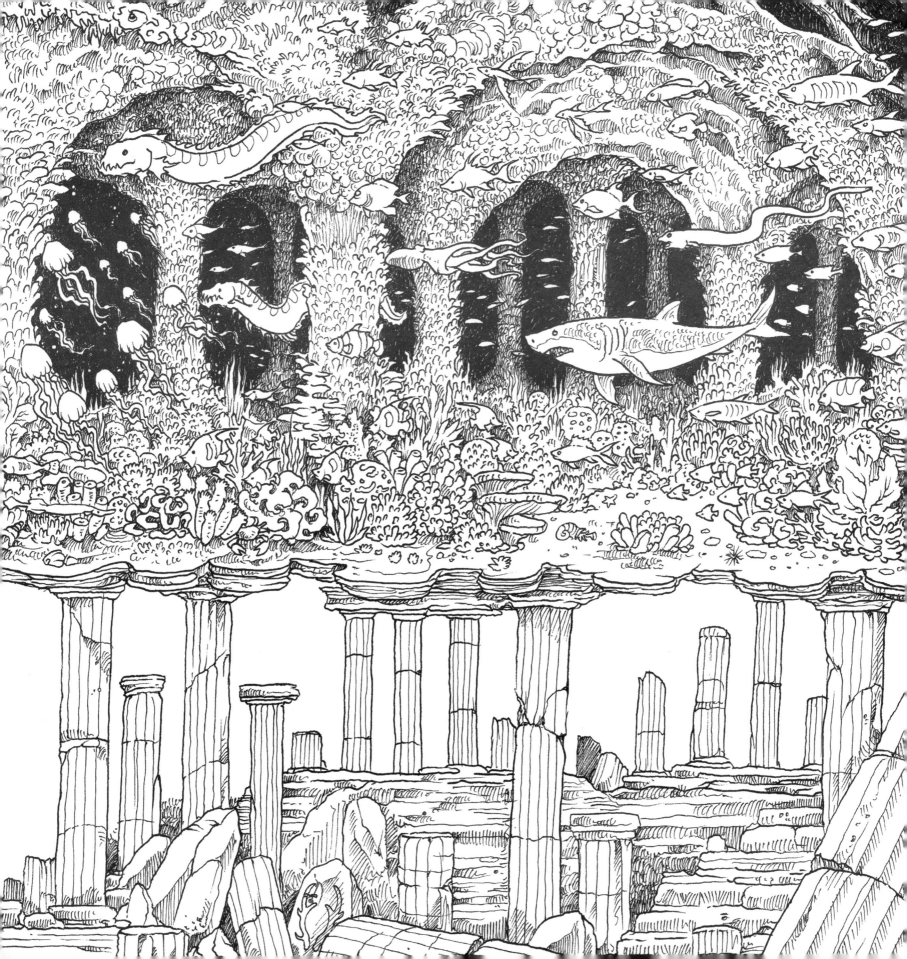

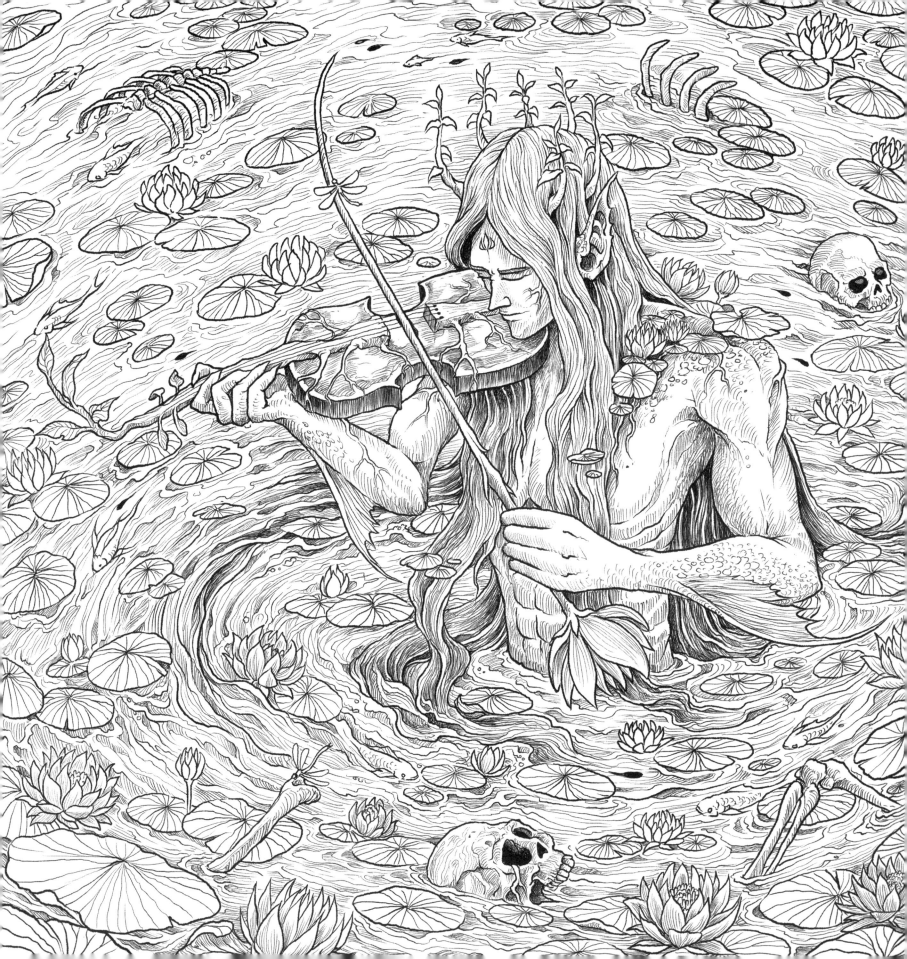

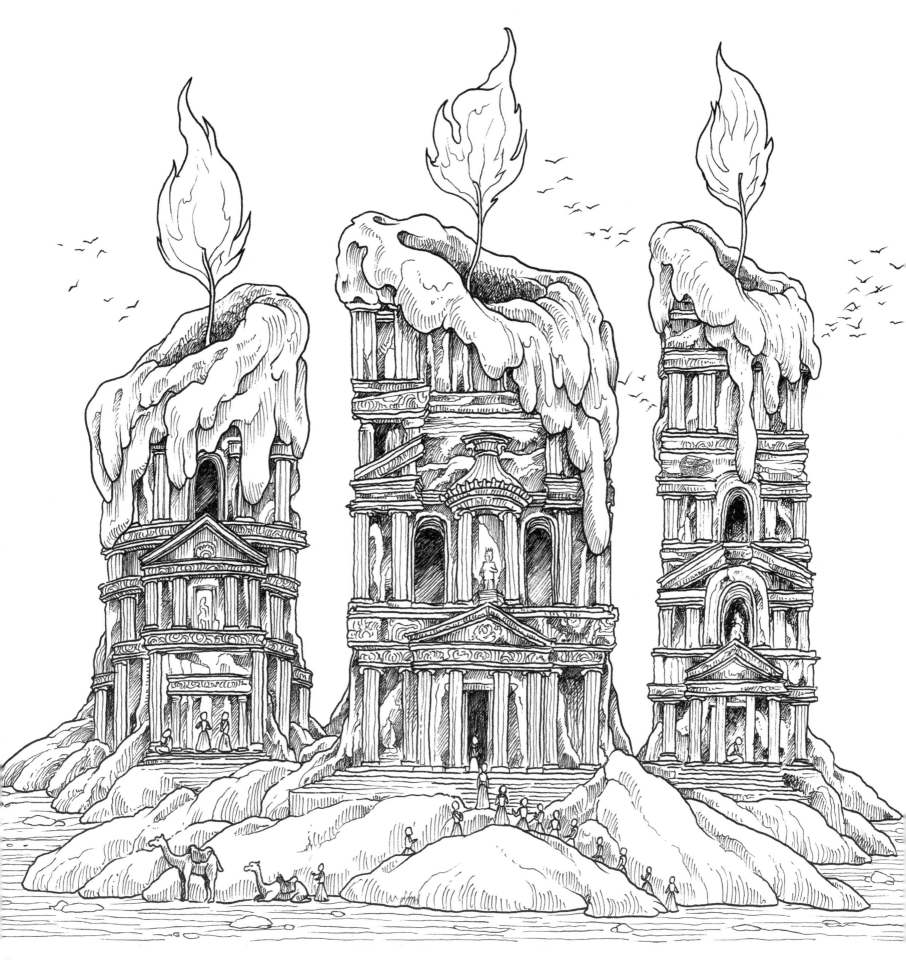

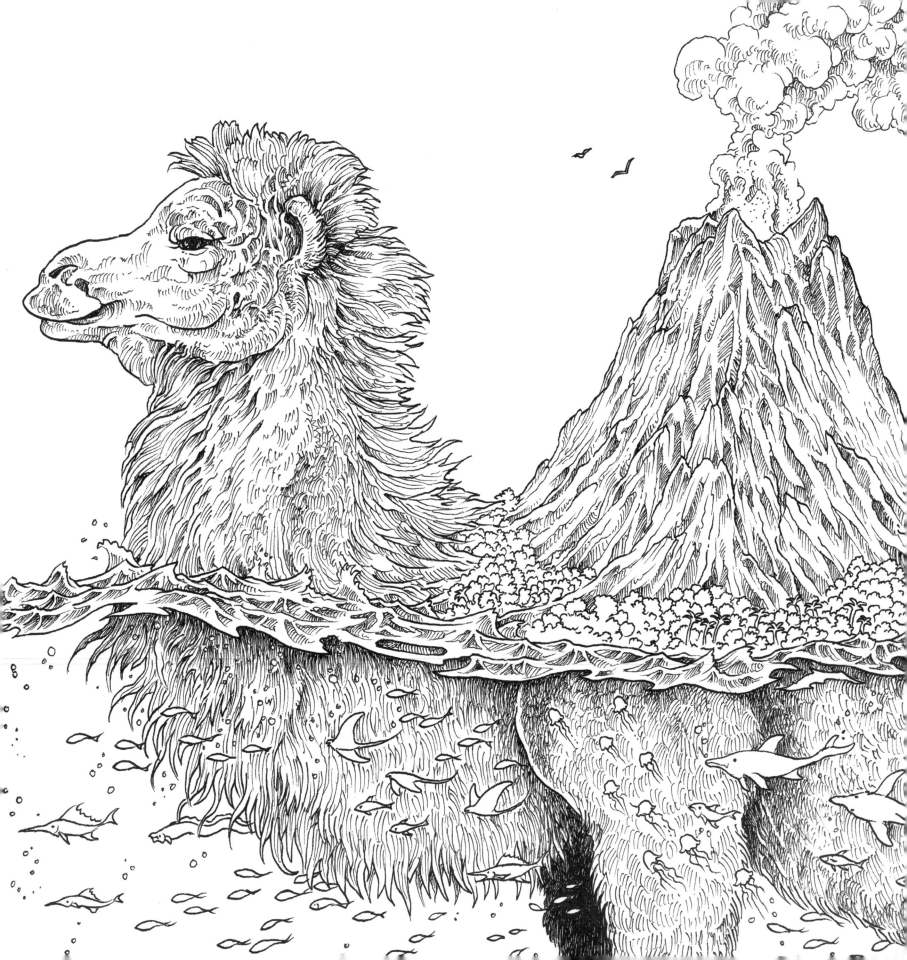

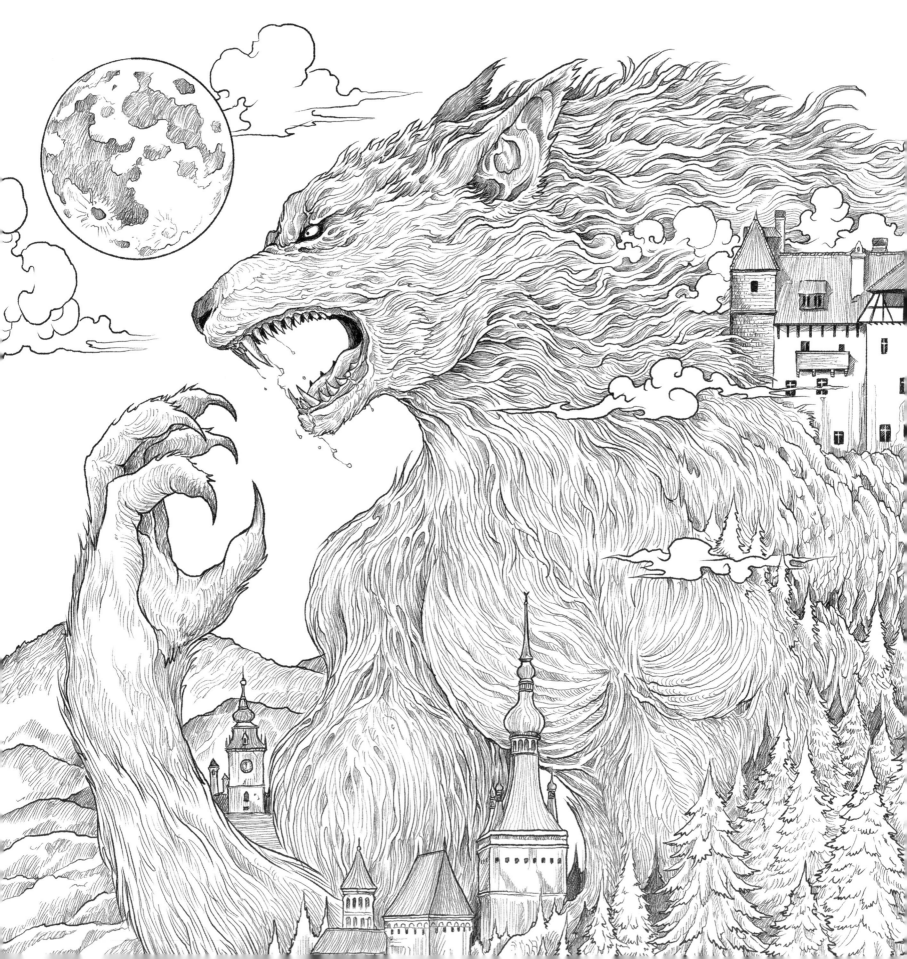

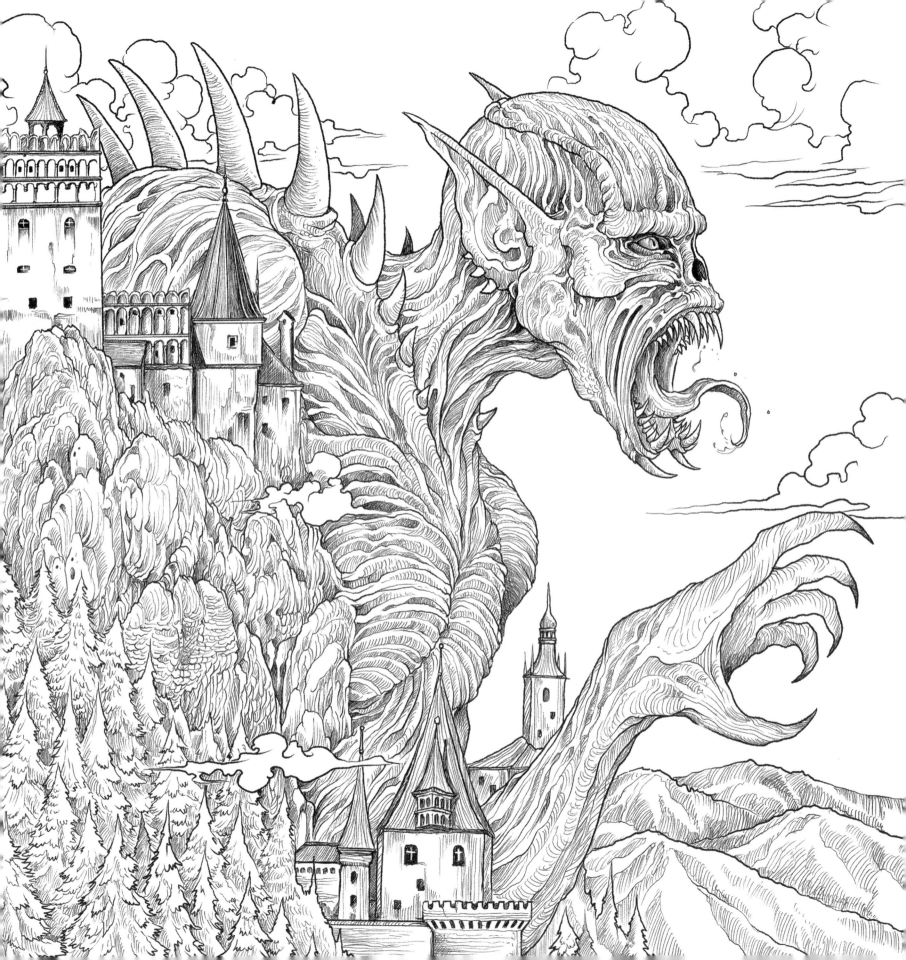

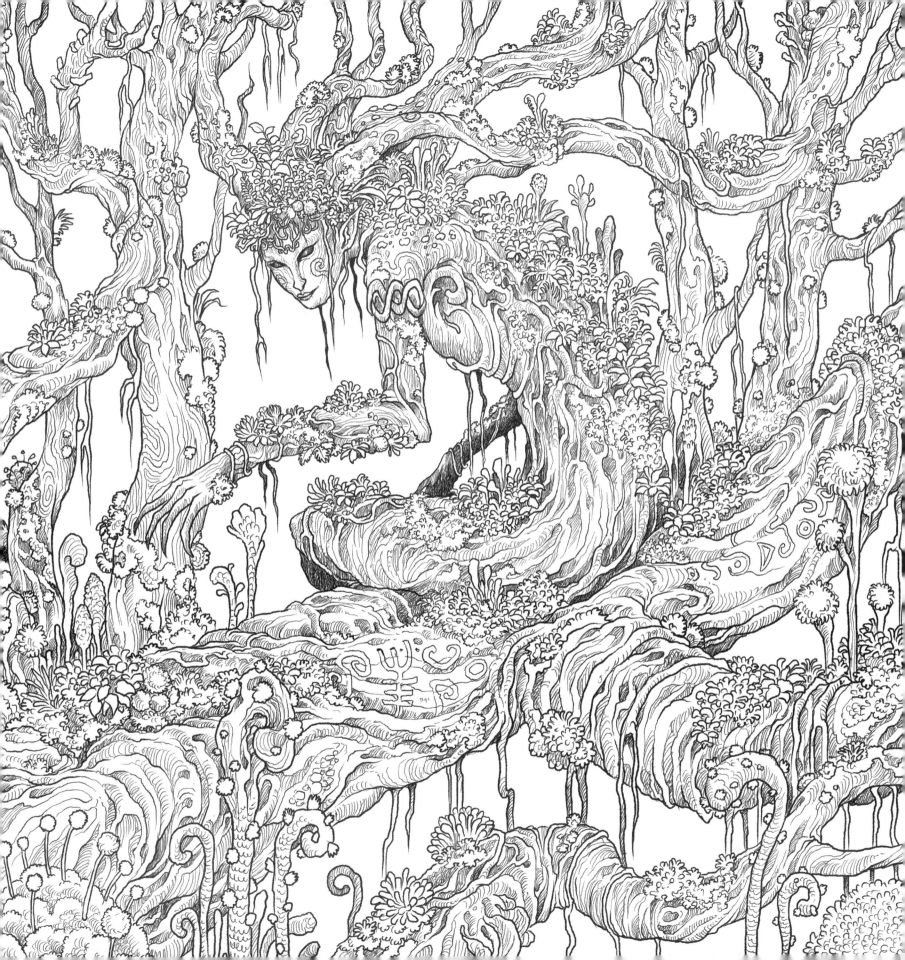

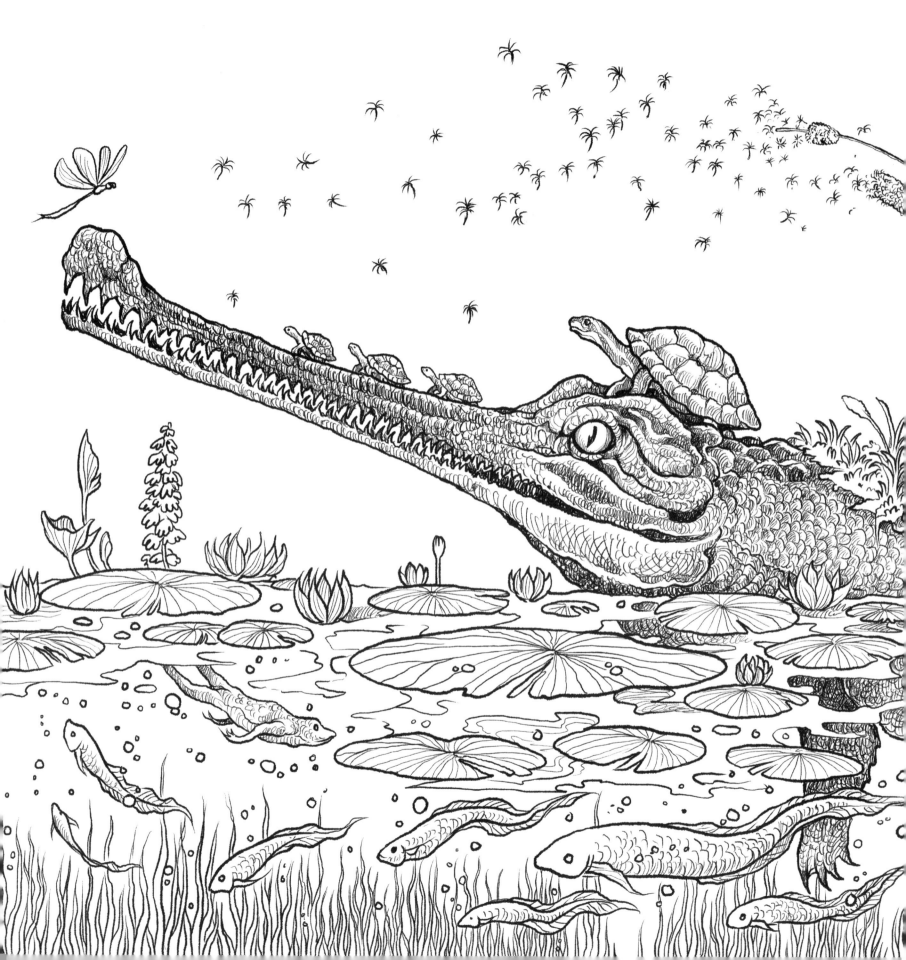

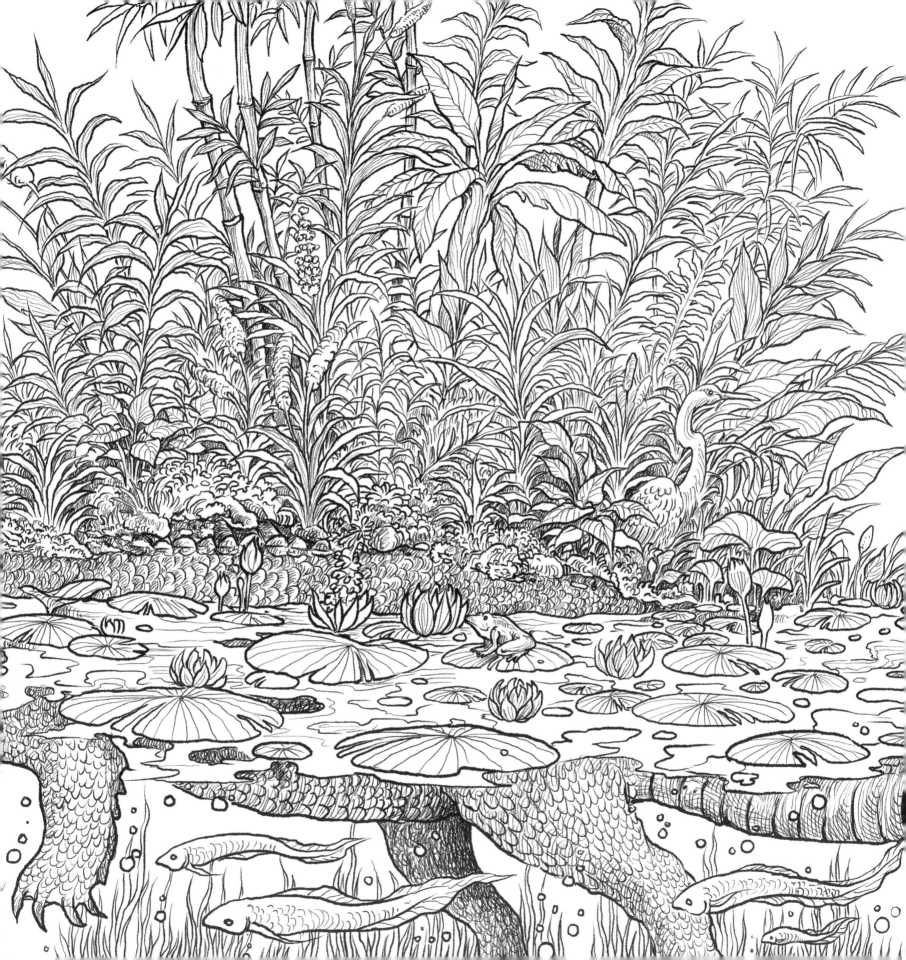

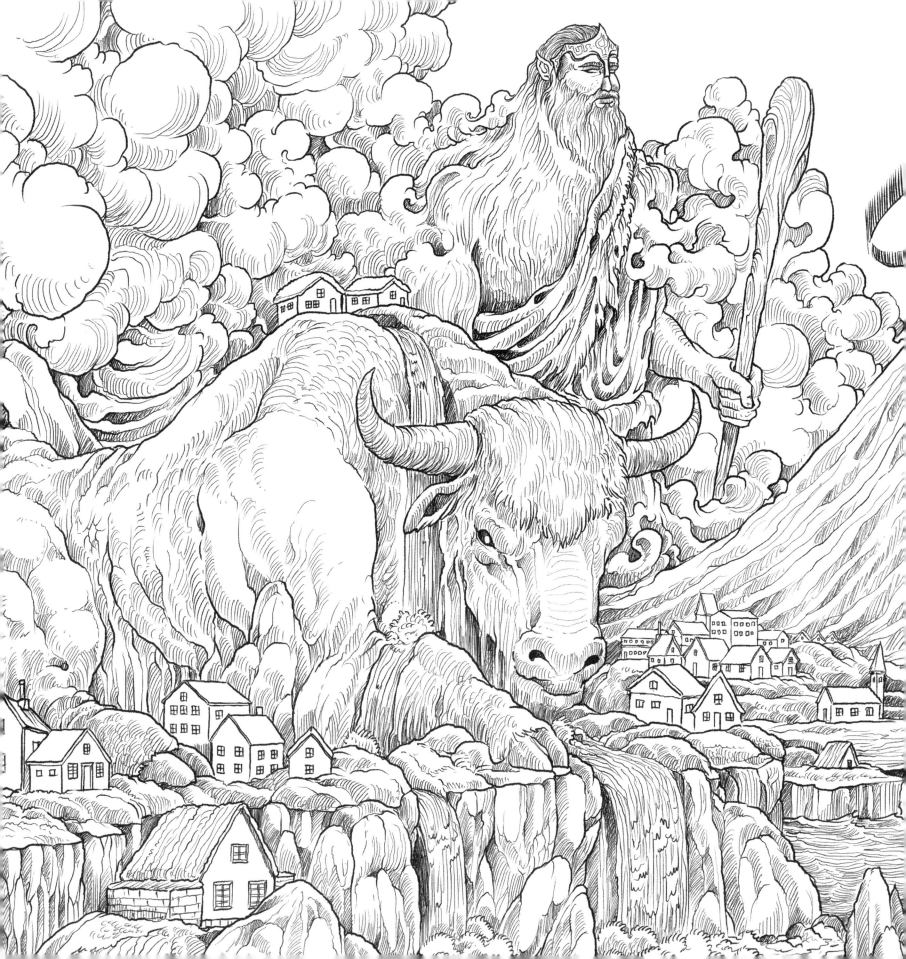

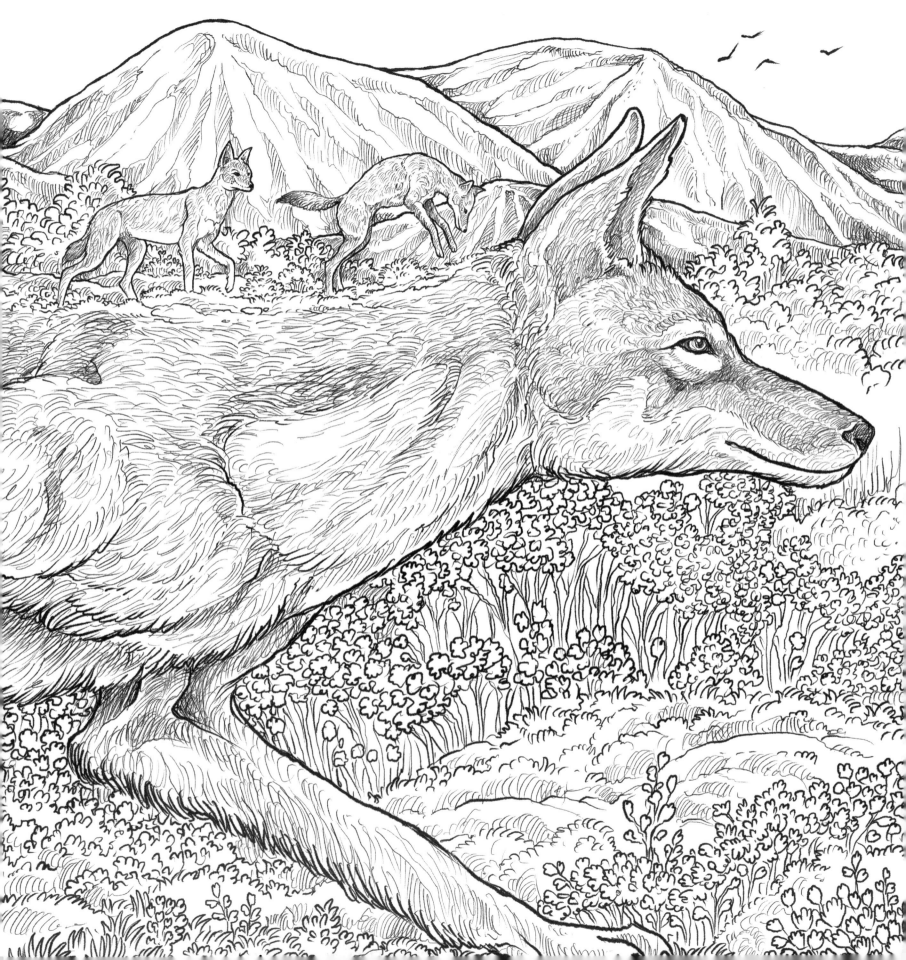

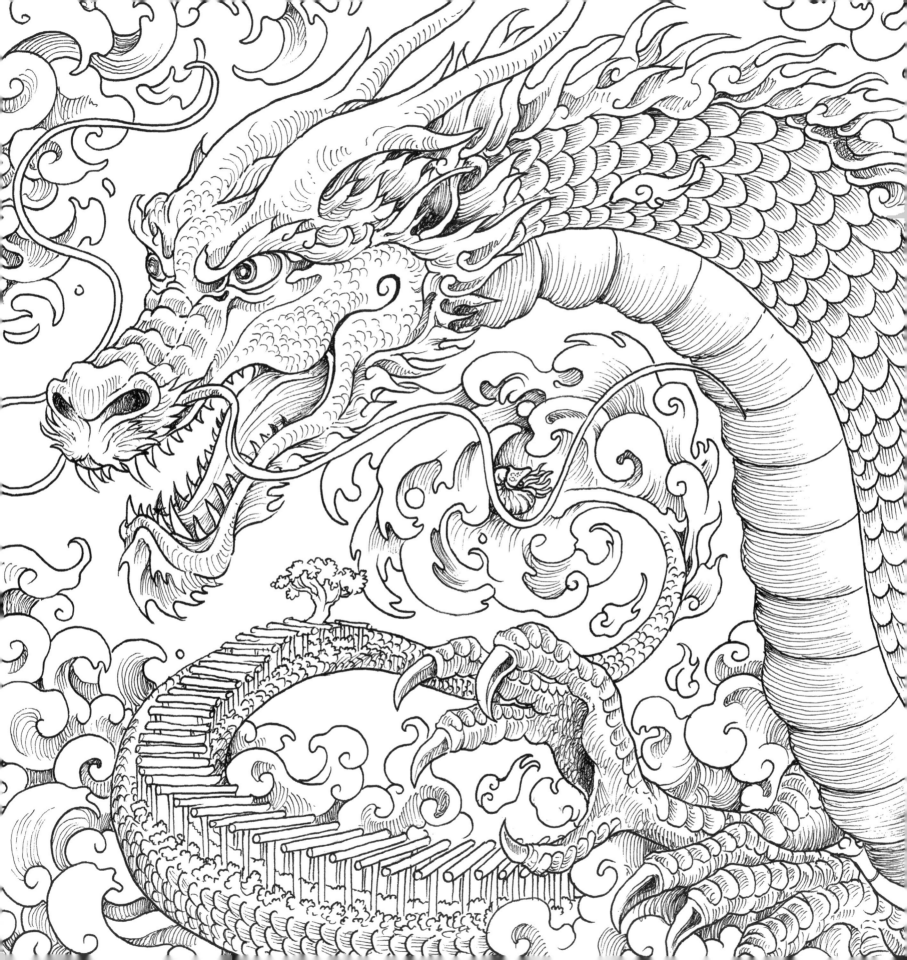

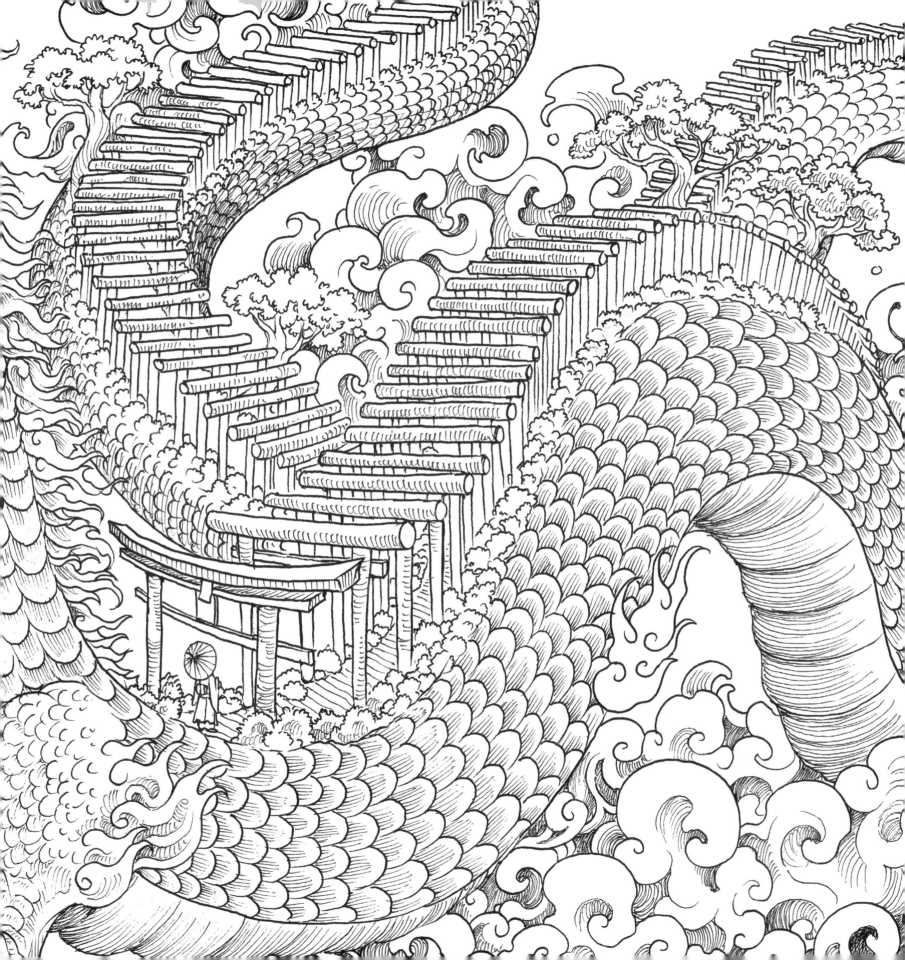

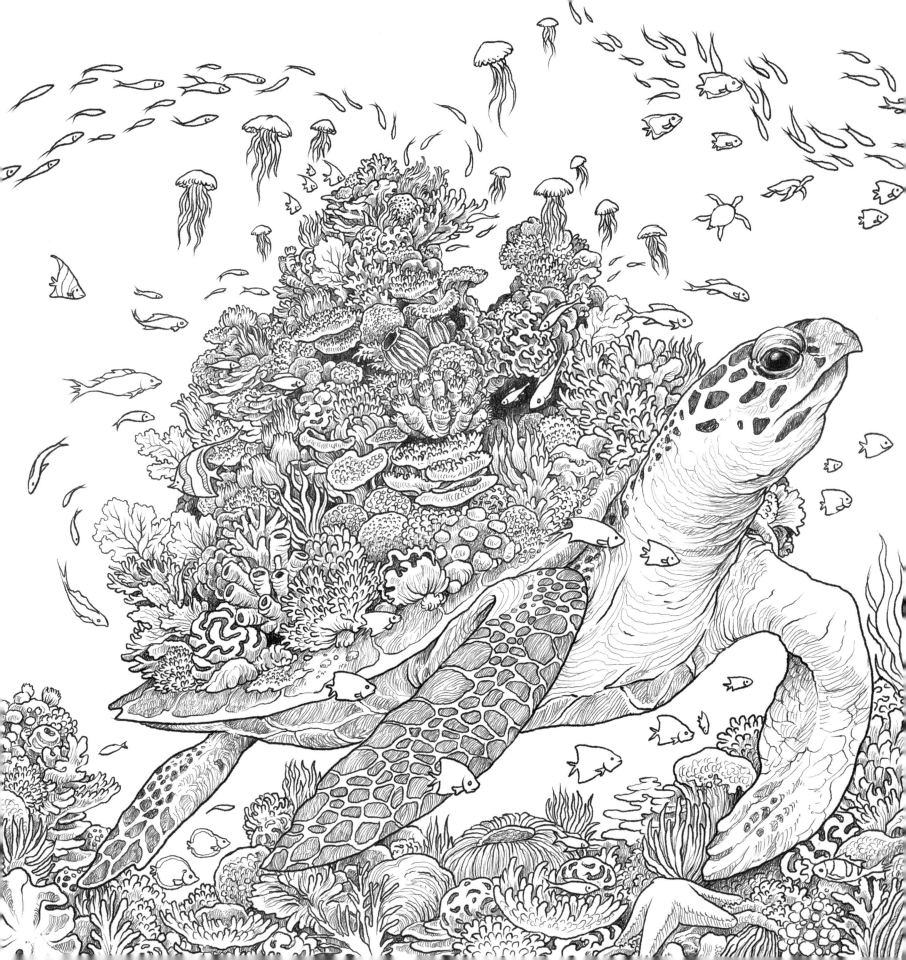

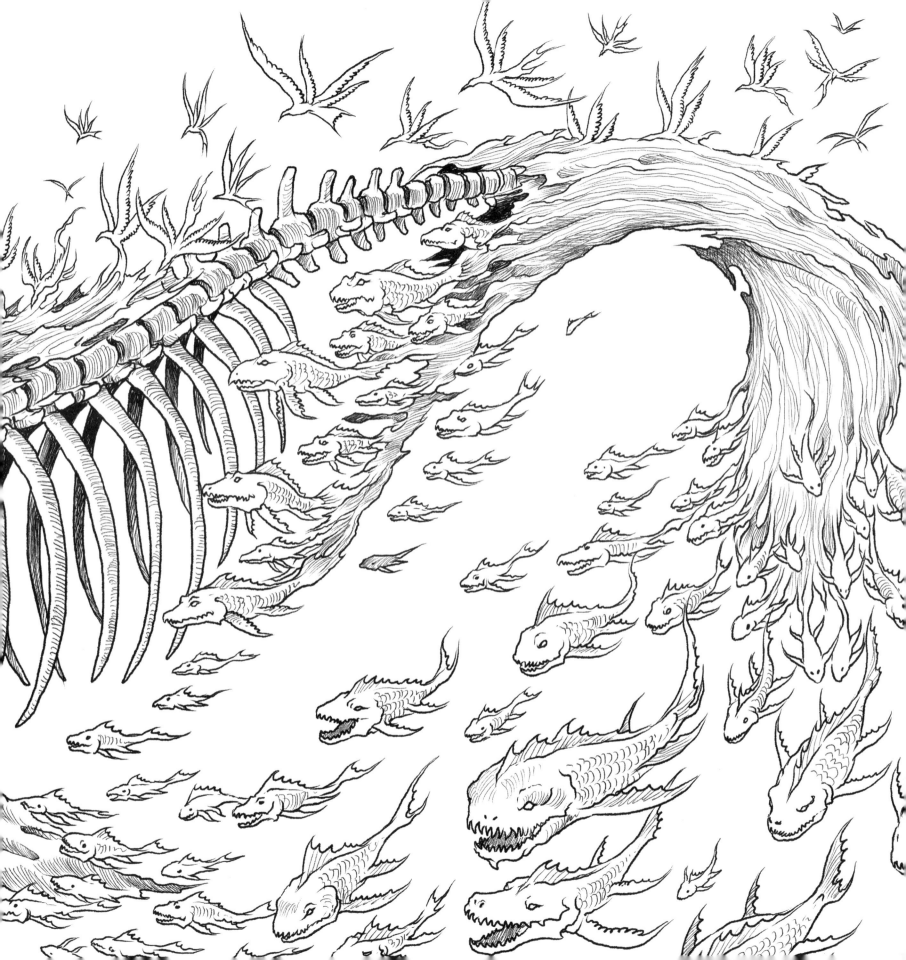

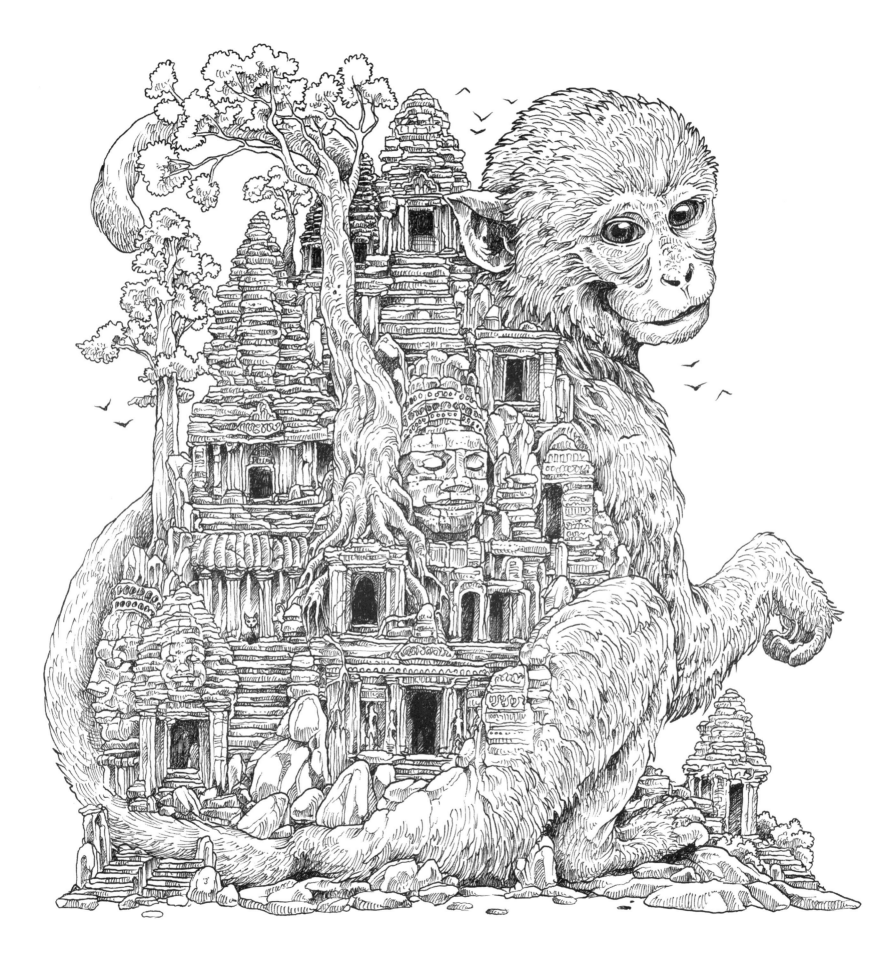

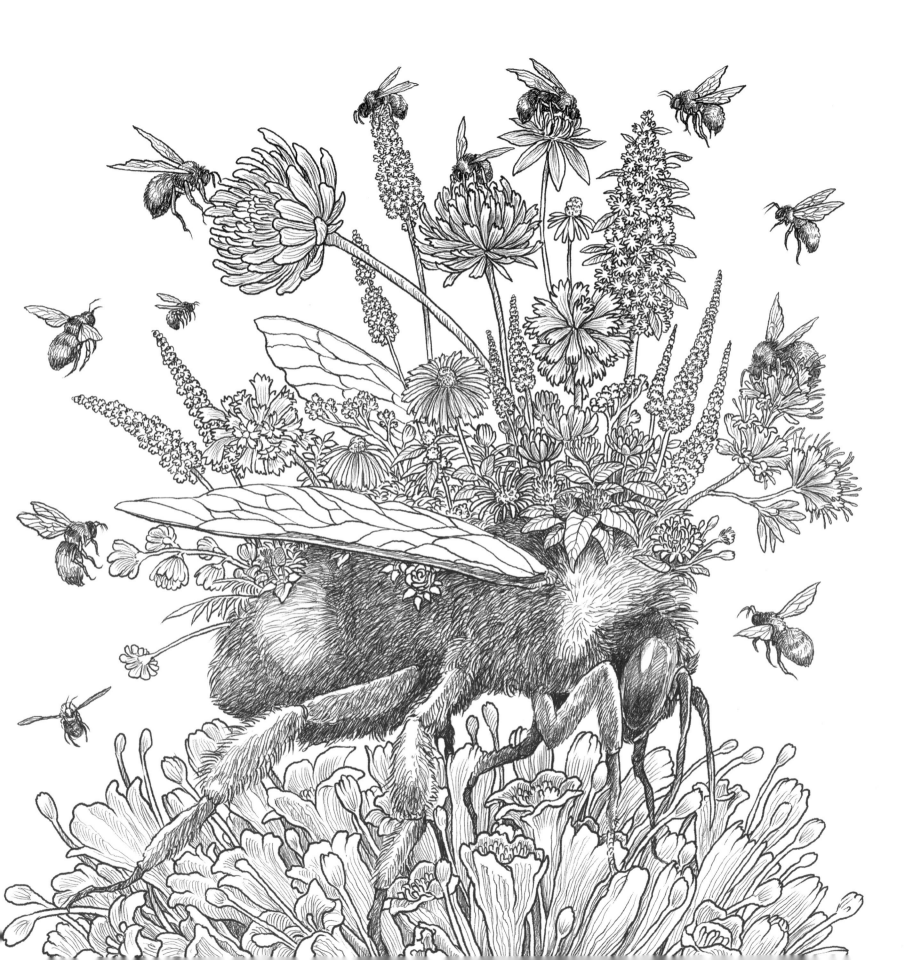

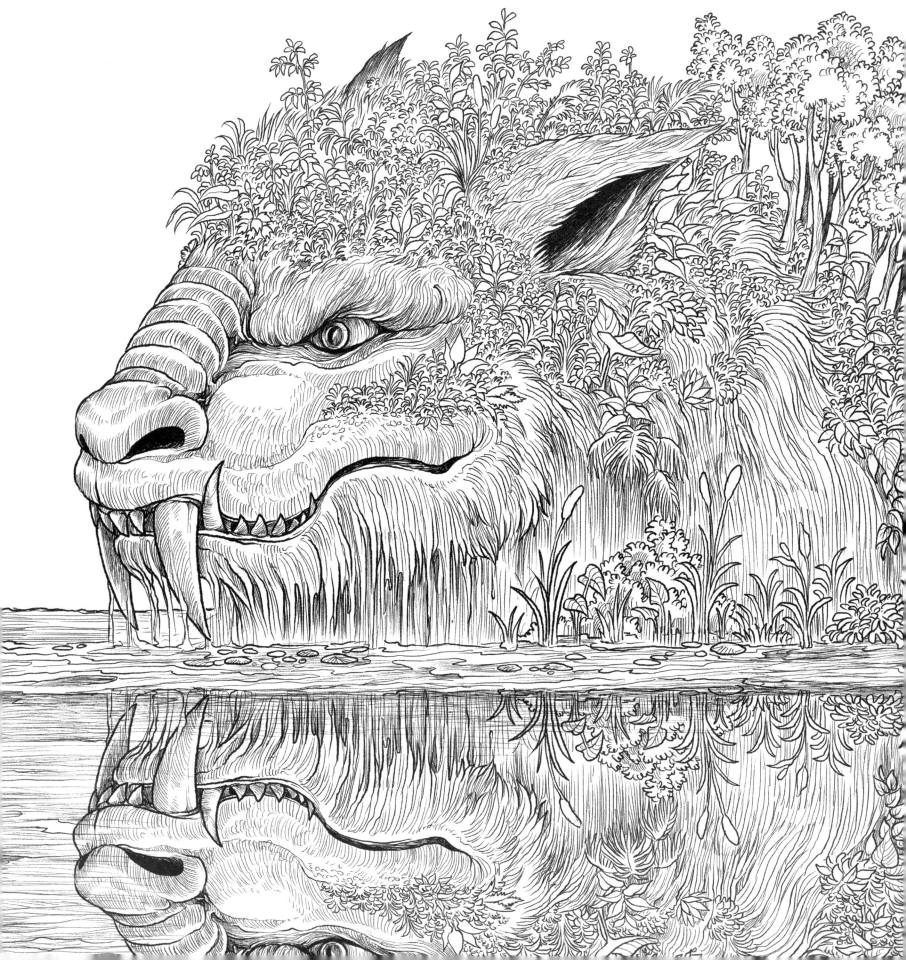

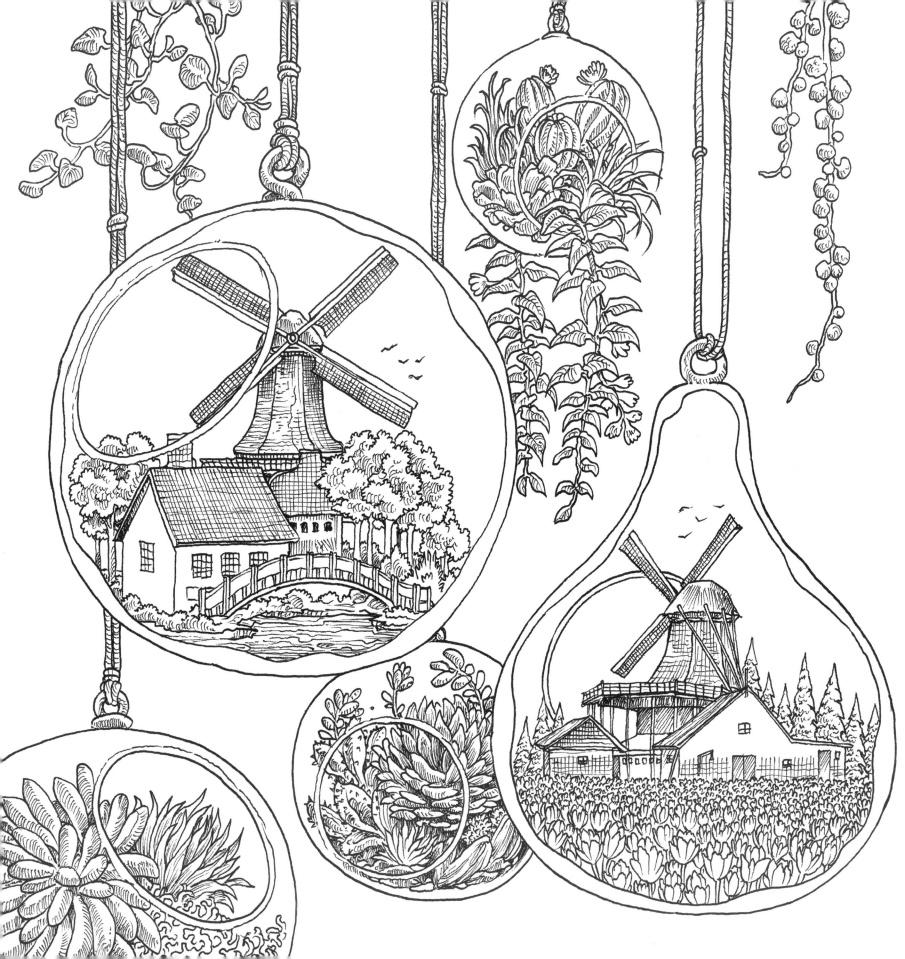

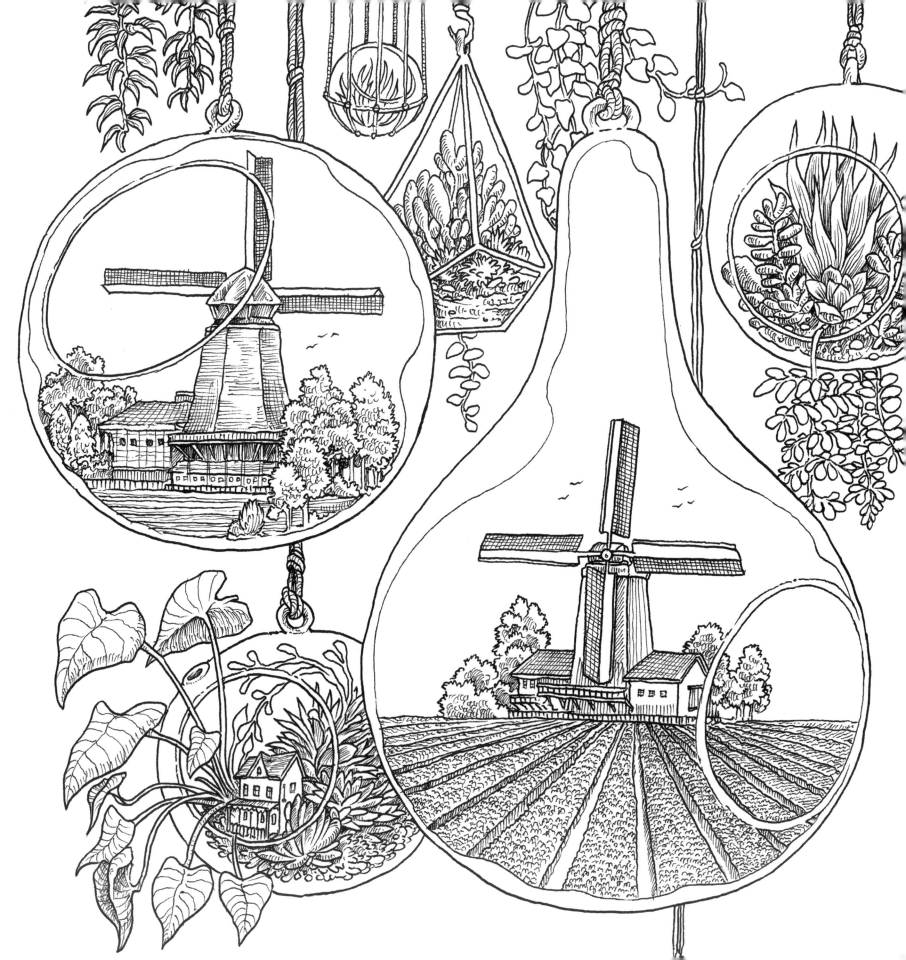

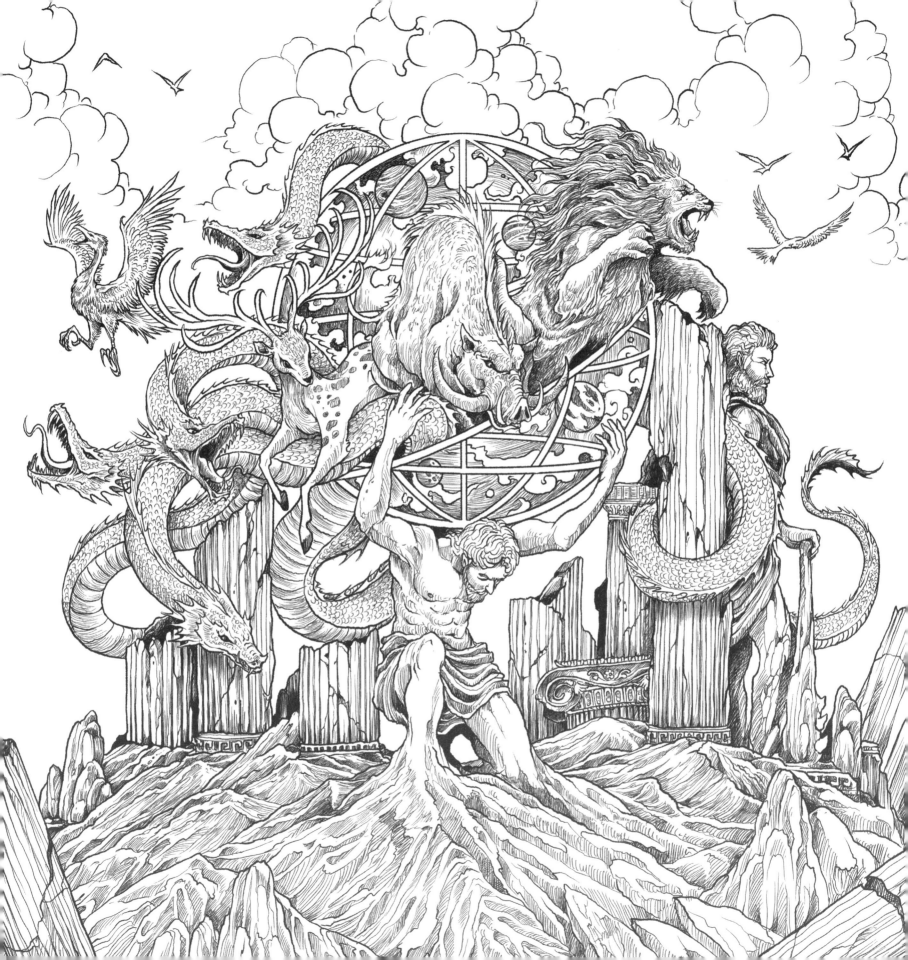

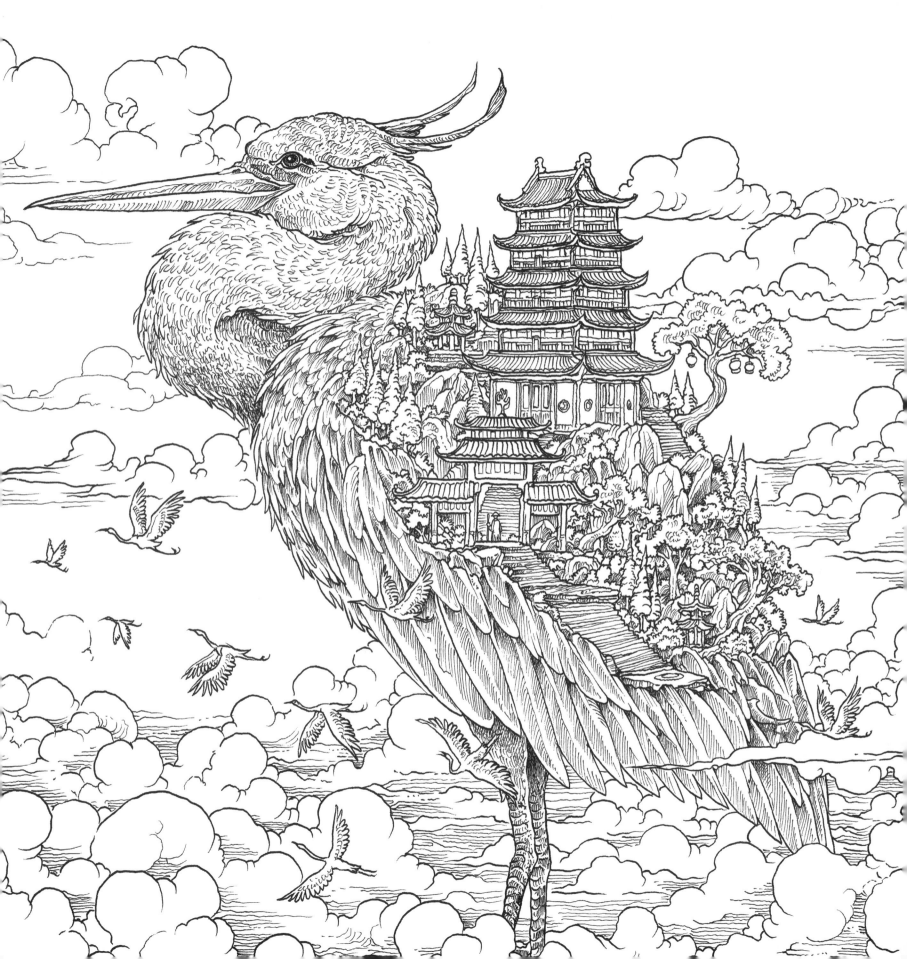

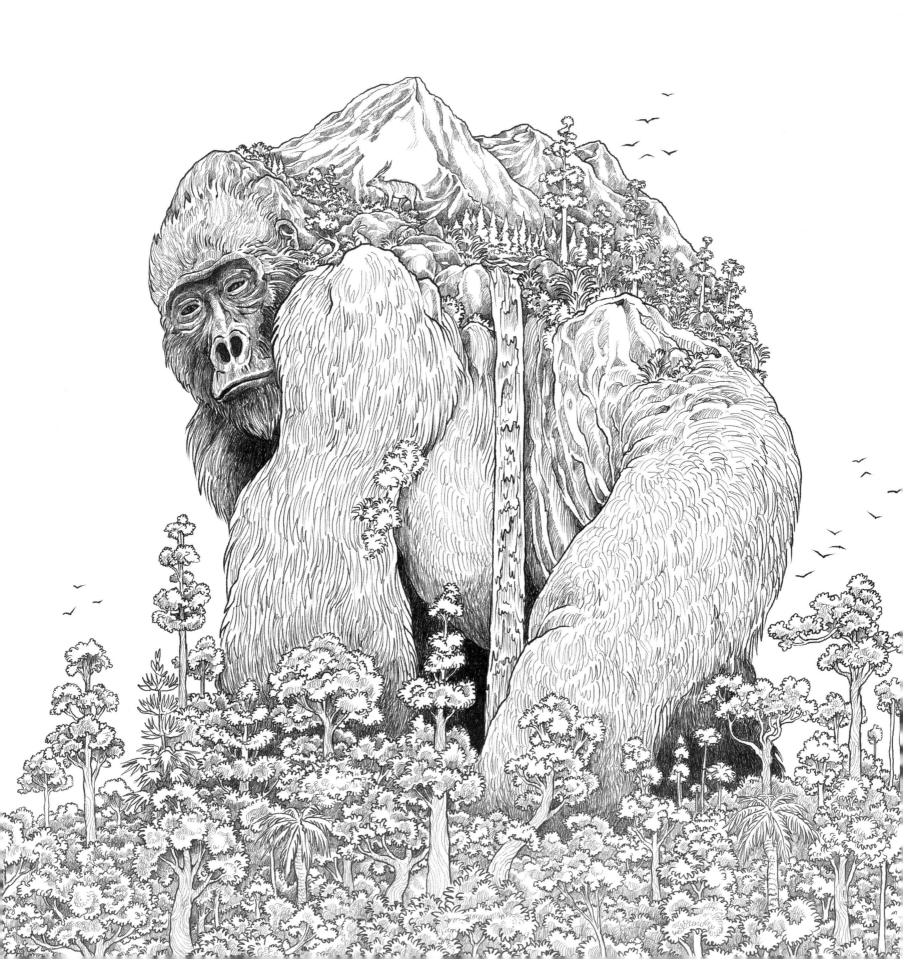

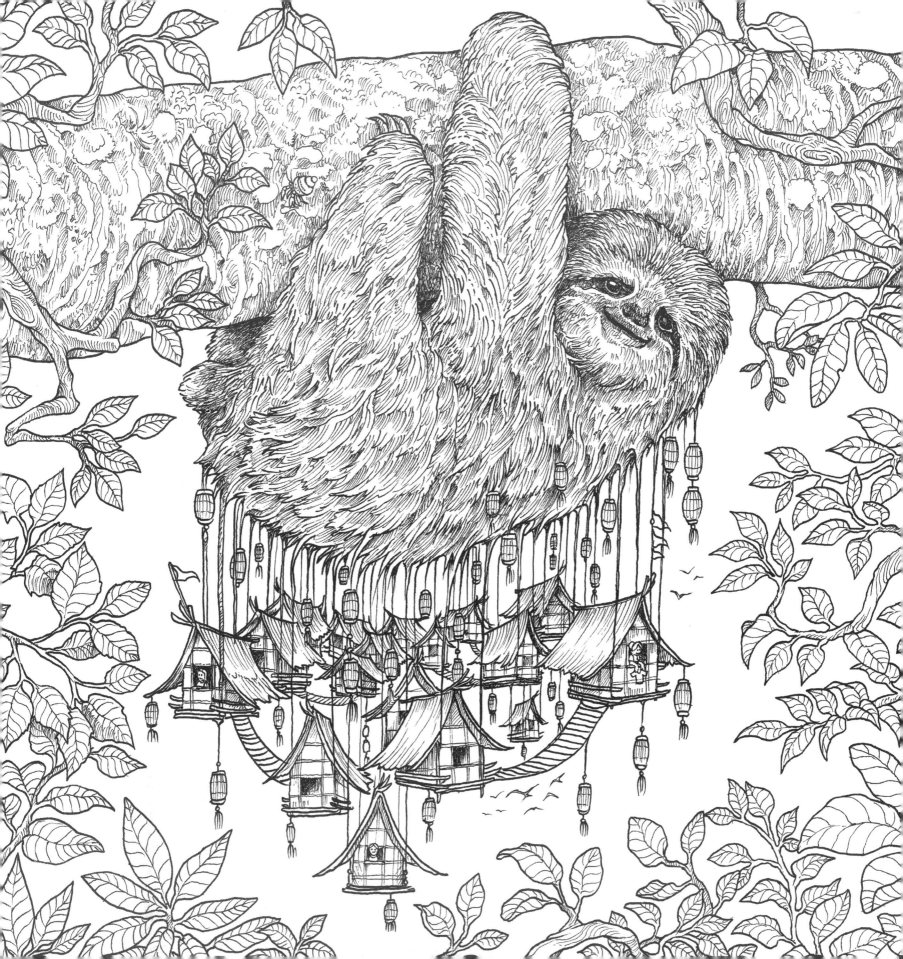

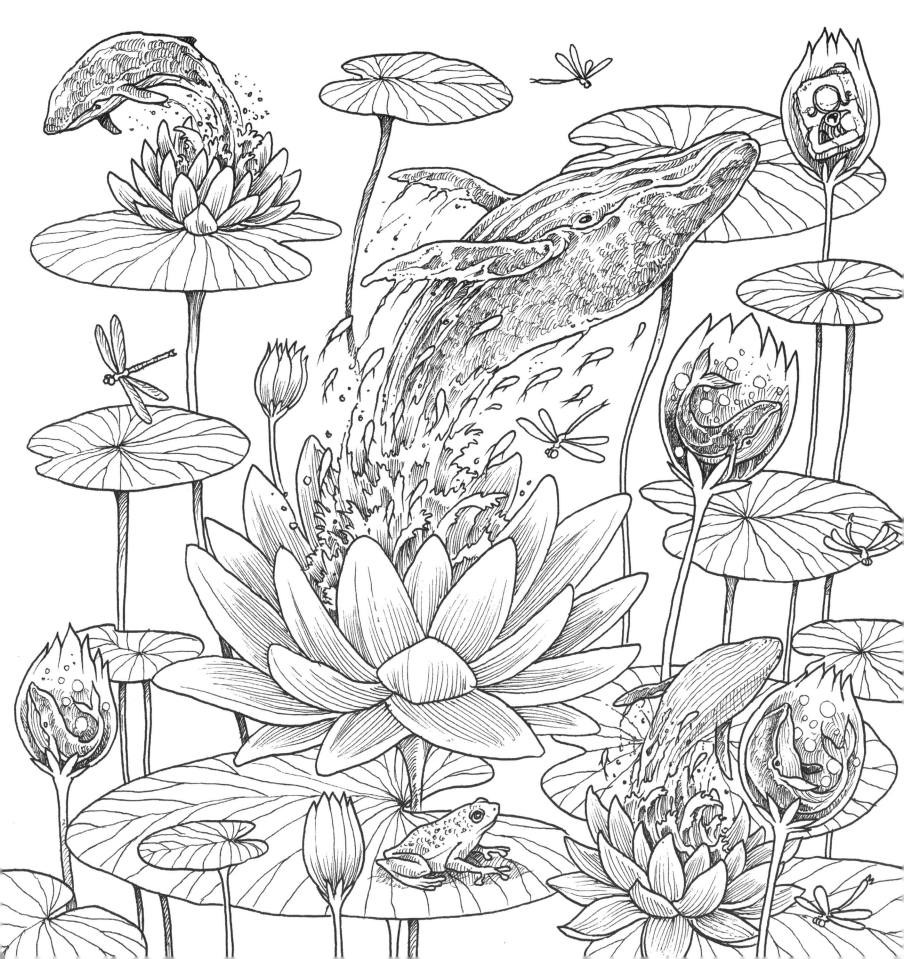

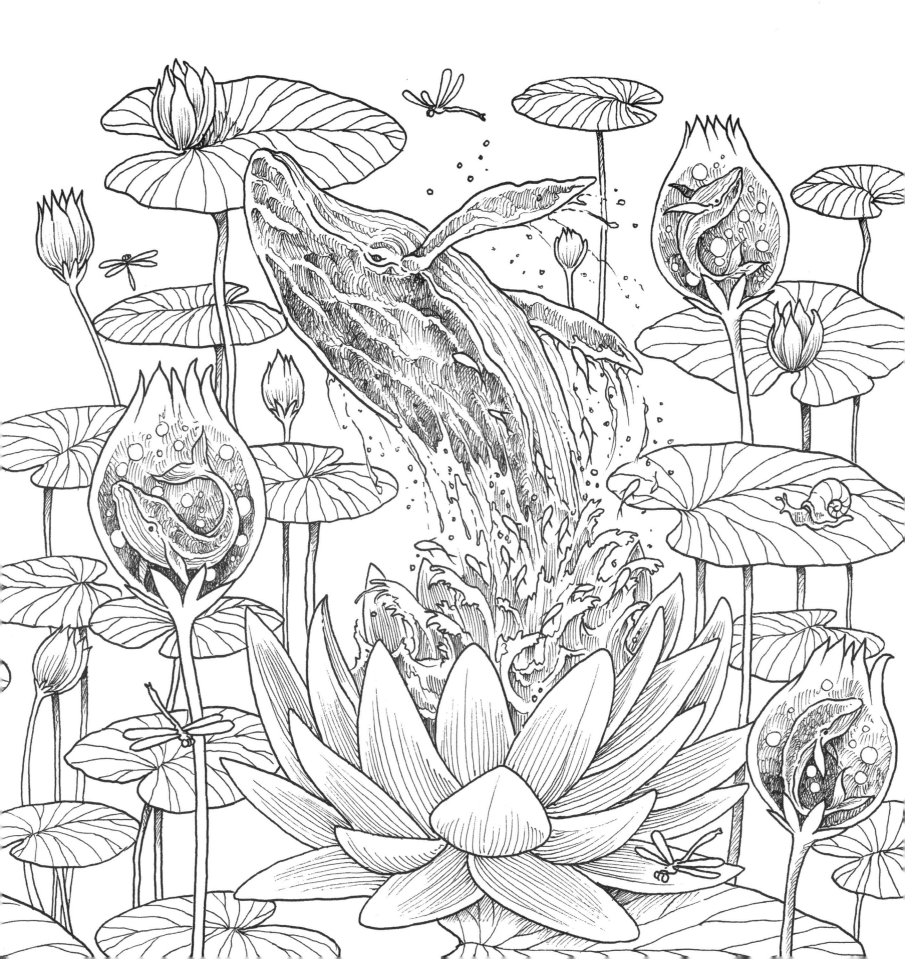

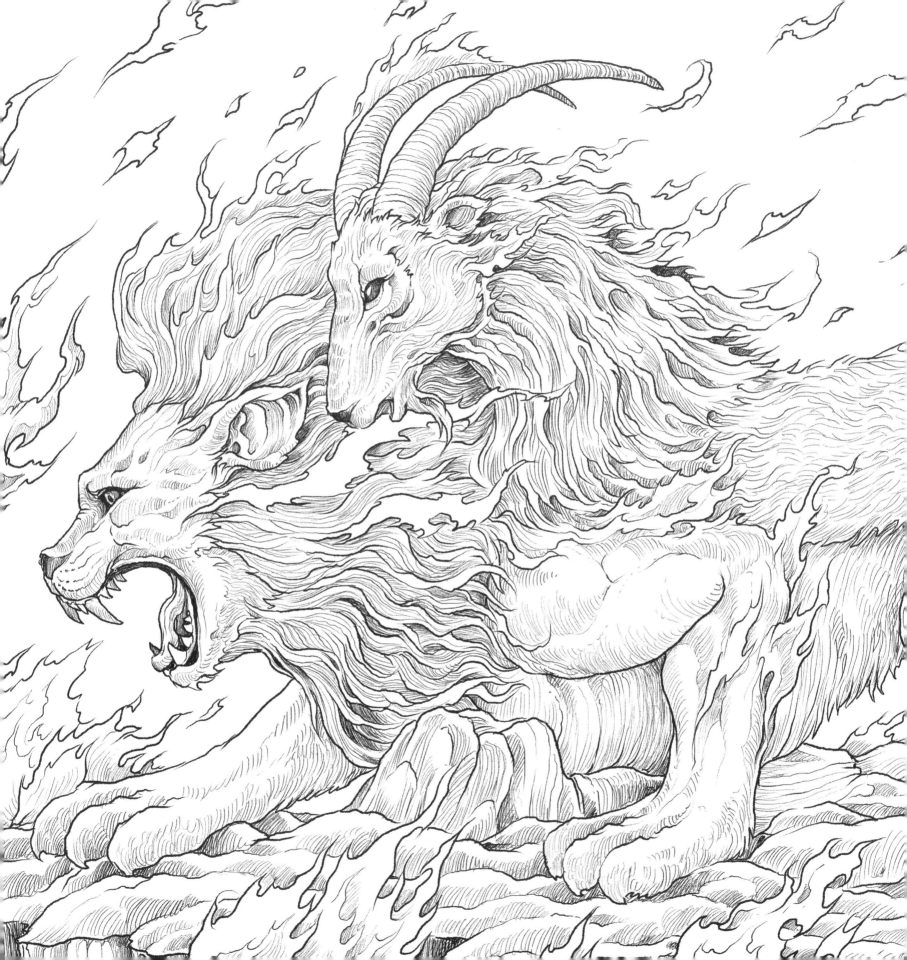

Illustrated by
Kerby Rosanes

Edited by Zoe Clark

Designed by Derrian Bradder

Cover designed by John Bigwood

Cover images colored by Lina Amir and
Lauren Farnsworth (Tiger and Butterflies)
and Elena Burtasova (Stork)

With special thanks to Harry Thornton

PLUME
An imprint of Penguin Random House LLC
penguinrandomhouse.com

First published in Great Britain in 2022 by LOM ART, an imprint of
Michael O'Mara Books Limited, 9 Lion Yard, Tremadoc Road, London SW4 7NQ

The material in this book previously appeared in *Worlds Within Worlds: Color New Realms*;
Fragile World: Color Nature's Wonders; and *Mythic World: Color Timeless Legends*.

W www.mombooks.com Michael O'Mara Books OMaraBooks lomart.books

ISBN: 9780593472095 (paperback)

Printed in the United States of America
1st Printing